ANTOINE D'AGATA
*1961

DAYANITA SINGH
*1961

GREGORY CREWDSON
*1962

NICK BRANDT
*1964

PAOLO PELLEGRIN
*1964

RINKO KAWAUCHI
*1972

JUERGEN TELLER
*1964

ZANELE MUHOLI
*1972

MARTIN SCHOELLER
*1968

VIVIANE SASSEN
*1972

WOLFGANG TILLMANS
*1968

PIETER HUGO
*1976

ALEC SOTH
*1969

RYAN MCGINLEY
*1977

RICHARD MOSSE
*1980

1960s 1970s 1980s

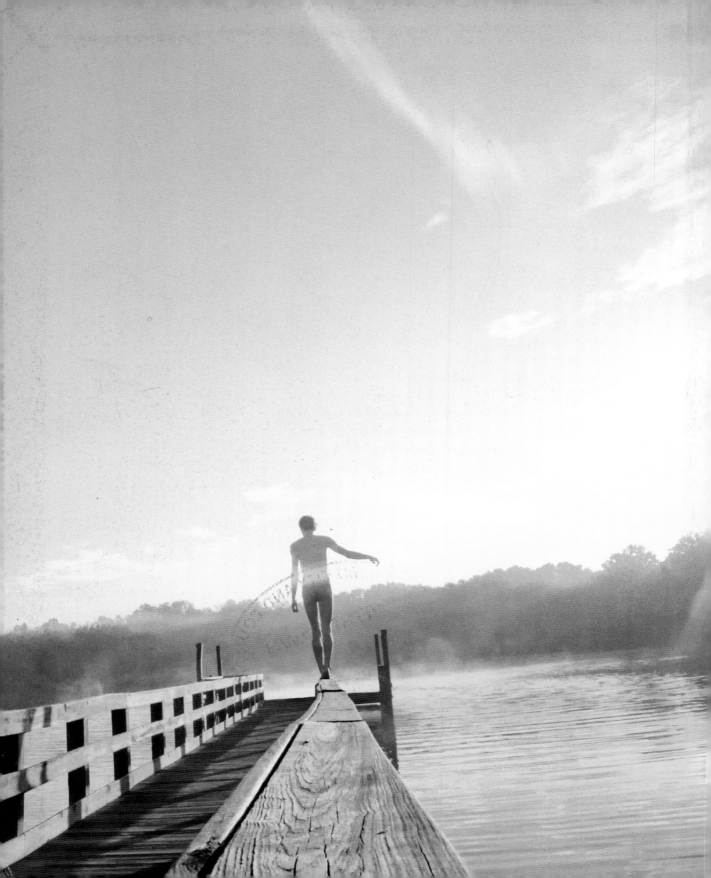

50 CONTEMPORARY PHOTOGRAPHERS

YOU SHOULD KNOW

Florian Heine
Brad Finger

PRESTEL
Munich · London · New York

CONTENTS

01

DAVID BAILEY

"Who do you think you are—David Bailey?" With a late-1970s advertising campaign for Olympus cameras, the portrait and fashion photographer, already a celebrity in his native United Kingdom, became a catchphrase.

DAVID BAILEY

1938 Born in London, where he lived during the Blitz

1956 Conscripted in the Royal Air Force, serving in Singapore

1960 Portrait and Fashion photographer for *Vogue*

1965 *Box of Pin Ups*. Bailey's first publication. Started directing commercials, documentaries, and films

1971 First national exhibition with David Hockney and Gerald Scarfe at the National Portrait Gallery

1976 Founded the magazine *Ritz Newspaper* with David Litchfield

2001 Commander of the British Empire

2014 *Bailey's Stardust*. Touring exhibition in London, Edinburgh, Milan, and Arles

To date Bailey has photographed more than 350 covers for *Condé Nast* and published over 30 books

He was the most famous photographer of his time and the inspiration for Michelangelo Antonioni's film *Blow-Up* (1966), in which David Bailey should have played the lead role. Fashion photography and portraiture constitute his most significant and substantial work. His portraits of London in the 1960s, documented its cultural revolution. "I never considered myself a fashion photographer. I've never really been interested in fashion. The reason I did fashion was that I liked what was in the frocks." Bailey was as famous as a photographer as the music, film, and fashion icons he had in front of his camera. In 1965, he "published" his *Box of Pin-Ups*, a series of thirty-six photos, not as a book but in individual gravure prints, featuring the musicians, actors, and artists who ruled London's pop cultural scene at the time—the "popocracy." At the same time it was a sort of photographic manifesto: "This sounds conceited, but I think one of the reasons I didn't go out of fashion is because I was never fashionable. I never really had a 'style.'… The pictures I take are simple and direct and about the person I'm photographing. I spend more time talking to the person than I do taking pictures." He was not afraid of being copied: "You can't copy my portraits, because I'm photographing my personality half the time, with their personality."

In the 1960s, fashion photography was dominated by black-and-white images of models on the streets of London and New York. In the 1970s, he injected energy into fashion photography by shooting in exotic locales like Turkey, South America, and India. And it was on these trips that he began discovering these countries for himself, publishing over the years photo books on Papua New Guinea, Afghanistan, and Australia as well as Havana, Cuba, Sudan, India and, his most recent books about London's *East End* (2014) and *Naga Hills*, forthcoming 2016.

"Photography—like painting—is all about looking for me. You have to keep looking until you see." Fortunately, David Bailey appears to have not yet seen enough. Today it is hardly possible to understand the innovative contributions he made not only to his own field, fashion and portrait photography, but also to films and TV documentaries and the sensational notoriety that he long enjoyed as a photographer. In 1976 he founded his own magazine, *Ritz*. Originally conceived as a transitional project with which to have some fun, the magazine survived until 1992, and its celebrity pages established the cult of paparazzi so prevalent today.

Di James, Bailey's former studio manager, said, "Bailey can never stop taking photographs. His camera is an extension of his right arm and his right arm is governed by his eye. He just can't stop."

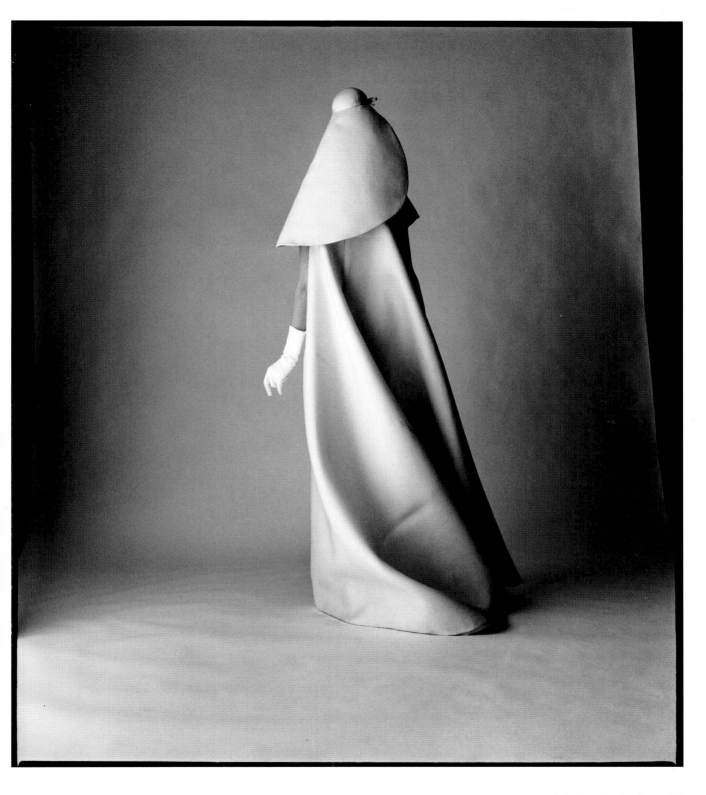

Balenciaga, American *Vogue*, 1967

JOSEF KOUDELKA

"I photograph only something that has to do with me, and I never did anything that I did not want to do. I do not do editorial and I never do advertising. No, my freedom is something I do not give away easily." So says Josef Koudelka, one of the art's most impressive practitioners, who left an indelible mark on twentieth-century photography.

JOSEF KOUDELKA

www.magnumphotos.com

Josef Koudelka was known in the former Czechoslovakia as an expressionistic theater photographer. During the Prague Spring of 1968 he photographed the invasion of Russian troops and managed to have the images smuggled out of the country and delivered to Elliott Erwitt, then president of Magnum. They were published in 1969 on the anniversary of the invasion and became famous—the photos that is, not the photographer, who was awarded the Robert Capa Gold Medal anonymously that same year. In order to protect him, Koudelka's authorship was kept a secret and the photos were attributed instead to P. P. —"Prague Photographer"—a ruse that Koudelka maintained even after emigrating to England in 1970. Only in 1984 did he admit that the photos were his.

By then, Koudelka had achieved renown with his other photo projects. His book *Gypsies* was published in 1975, and it did away with the kitschy romantic notion of the Gypsy to present the reality of the lives of the Sinti and Roma: the poverty as well as the traditions and poetry of these people living scattered across Europe. Koudelka himself lived the life of a nomad. During his longest period without a permanent home—apart from the Magnum Paris office and the London apartment of his colleague David Hurn—he traveled the breadth of Europe and photographed whatever interested him. The result were pictures of dark poetry, filled with power, imagination, and a rarely matched engagement. Koudelka is the true poet of photography and represents, as it were, the ideal of street photography, which unites more than any other genre of photography the essential elements of the art: observation, imagination, an attentive eye, and a feel for people and places.

"I do not say anything about my pictures. The pictures should speak to the viewer, not vice versa," comments the photographer. Unlike in abstract art, in photography there is always a real point of reference: the subject. But what does the subject say? What does it say to the photographer, who considers it worth capturing; and what does it say to the viewer who sees it? For some, photography is perhaps less a medium of expression than a medium of impression. Koudelka collects impressions that affect him and he puts them into photographic form. But what do the images say? They tell of a melancholy, mournful eye. The mother of one of his children said to him, "Josef, you go through life and get all this positive energy, and all the sadness, you just throw it behind you and it drops into the bag you carry on your back. Then, when you photograph, it all comes out." Koudelka feels that there may be some truth to this statement.

Since the photographer himself remains silent about his pictures, we will let the words of another poet of the camera, André Kertész (1894–1985), serve as a perfect summation of the work of Koudelka, whose most important advice to young photographers is to wear comfortable shoes, because "with every step in the real world, an abyss of poetry can open up."

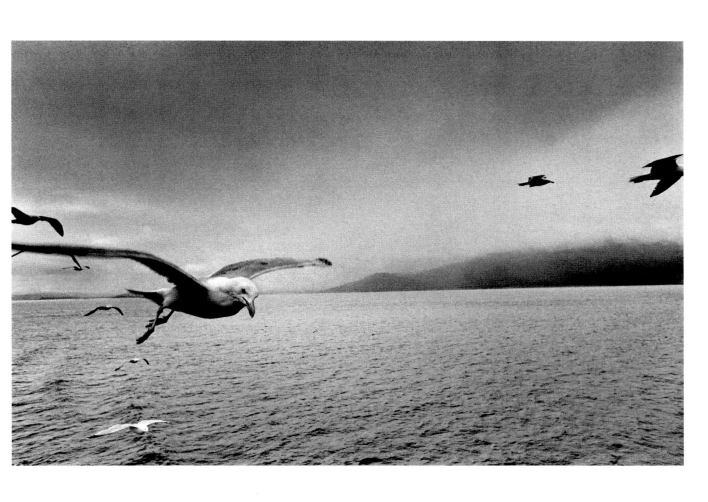

United Kingdom, Scotland, 1977

03

JOEL MEYEROWITZ

That chance or even fate plays a role in street photography American photographer Joel Meyerowitz knows well enough. Particularly at the beginning of his career, when after an encounter with Swiss photographer Robert Frank, he quit his job to himself become a photographer.

Joel Meyerowitz is one of the best-known exponents of street photography, which, in a line starting with Paul Strand and continuing to Henri Cartier-Bresson, Robert Frank, Josef Koudelka, and Daido Moriyama, has always been one of the most direct forms of practicing the photographic craft. A unique art form, photography is the only medium that allows you to create an image in a split second and capture and preserve life as it exists at a precise moment. Street photography is, as it were, the artistic sister of reportage; because it is in some sense without purpose, the boundaries are naturally fluid. It is the art of singling out a special lyrical moment from the flow of time. "Photography is a response that has to do with the momentary recognition of things. . . . You look one moment and there's everything, next moment it's gone. Photography is very philosophical," said the native New Yorker.

As in most fields of photography, for a long time color played an insignificant role within street photography. While many adhered to Robert Frank's dictum that "black and white are the colors of photography," there was also a financial reason; namely that because of the material-intensive nature of photography, the high costs of developing color film and prints meant that black and white was simply more affordable. As Ernst Haas (1921–1986), one of the pioneers of color photography, put it, "The dilemma with color is still the impossibility of doing prints as freely and easily as in black and white. If that were possible, the whole so-called art market, with its incomprehensible hostility toward color, would radically change." And that is exactly what happened—today more than ever—with Joel Meyerowitz, along with Stephen Shore and William Eggleston, the principal figures of the "New Color Photography." For Meyerowitz, color is "a half step closer to reality."

His first book, *Cape Light* (1978), became a classic of color photography. It was created in Cape Cod, where Meyerowitz captured the soft light and delicate colors of the seashore with an 8×10 camera rather than the Leica with which he photographed the bustling metropolis. Over the course of his fifty years as a photographer, Meyerowitz has become a chronicler of his native New York, and in the 1980s he expressed the aspiration to create a work that "says this is how it feels to be alive in New York City." He also documented the city's most trying time after the terrorist attacks of September 11, 2001, later published in his book *Aftermath*. Though prohibited, Meyerowitz repeatedly returned to Ground Zero in the days following the attacks, compelled to capture it all in photographs. He ultimately became the only photographer granted official permission, and for months he documented the work in the restricted area, and continued to do so in the changing neighborhood until 2010.

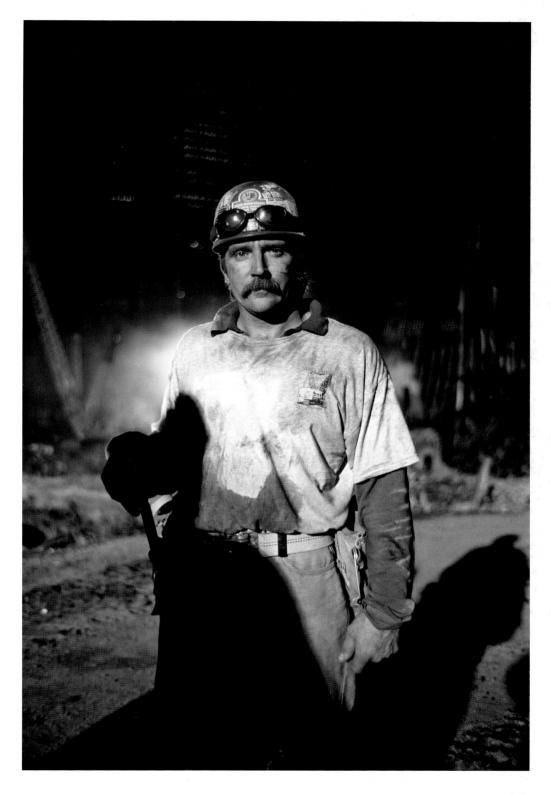

A Welder Wounded by an Explosion of Buried Ammunition in the Customs Building, New York City, 2001

13

New York City, 1975

04 BORIS MIKHAILOV

The more you know, the more you see. This rule is especially true of works of art from an era and a political system that was long hidden behind a curtain. Boris Mikhailov is the most important photographer of the former Soviet Union and whose images make him the chronicler of his time.

BORIS MIKHAILOV

1938 Born in Kharkiv, Ukraine

1962 After studying electrical engineering, worked in a camera factory in Kharkiv

1971–85
 Luriki series, hand-colored family photos

1975–86
 Sots Art series, everyday scenes on political subjects

1981 *Crimean Snobbism* series

1985 *Unfinished Dissertation* series

1994 *If I Were a German* series

2000 Hasselblad Foundation Award

2001 Citibank Photography Prize

2015 Goslarer Kaiserring

"It wasn't easy. But now it's too easy, and that's no good either. Prohibitions drive us to find new ways." So observed Ukrainian photographer Boris Mikhailov, who today lives between his hometown Kharkiv and Berlin. The former Soviet Union had, like all restrictive systems, strict rules that determined and controlled the political, social, and cultural life. Photographers had their own special rules, such as a prohibition on photographing railway stations and other such facilities from above a second-floor height, or taking pictures that could discredit the USSR and its achievements, or photographing documents. In the 1960s, Mikhailov was working as an engineer in Kharkiv when he lost his job after the KGB found nude portraits of his wife in his possession. He later reflected, "Communism had no religion with which to make people afraid, so it banned nakedness, not for any moral reasons but simply so that we would be ashamed of ourselves."

Mikhailov, who was a dedicated amateur, began to take photography seriously, and rather than circumventing the restrictions began to do precisely the opposite, following them to the letter. In response to the provision dictating that no image be taken that could discredit the Soviet lifestyle, Mikhailov shot the *Red Series* (1968–75), for which he photographed the regime's unending parades and agricultural exhibitions. He captured these repetitive, unchanging events and the bored faces of those in attendance, obliged to cheer. By looking closely and documenting what he saw, he unmasked the apparatus, depicting the absurdity of its rigid forms. His "conformist" compliance with the rules held them up to ridicule and a subversive criticism.

In his series *By the Ground* (1991), Mikhailov shot with the camera aimed down to the ground, lowering the viewpoint to satirize the Soviet regulation about taking pictures from an elevated standpoint as well as to comment on the destitute condition of Soviet citizens. With an economy of scarcity prevailing as the Soviet Union crumbled, Mikhailov responded to a shortage of paper by printing four photos on a single sheet, making palpable the economic conditions and also allowing unexpected associations to arise between the images. He found truly artful ways to deal with Soviet restrictions. And yet, we as outside observers need information about Mikhailov's methodology in order for his work to have its full impact. That the regime was still not pleased is evidenced by the fact that, despite his numerous photo cycles, Mikhailov did not have an official exhibition in the USSR until 1990.

After the collapse of the Soviet Union, life changed radically, and Mikhailov responded with his shockingly striking series *Case History* (1997–98). In 400 photographs of the Ukraine, he documented the extreme effects of rampant capitalism: "The collapse of the state was also a collapse of civilization," he observed. The work was centered on people often hidden from society—the homeless, prostitutes, alcoholics, street children—putting faces on them and giving them a presence.

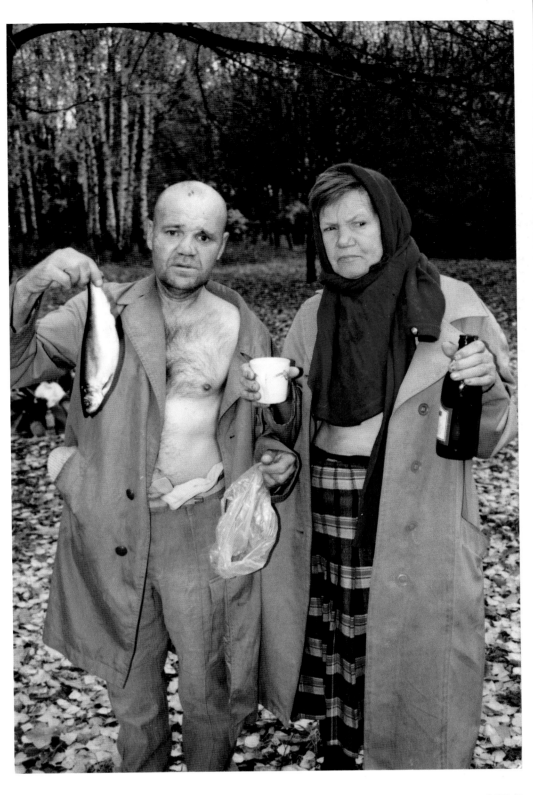

From "Case History," 1997–98

05 DAIDO MORIYAMA

Daido Moriyama's most famous photo features a stray dog, which is how the photographer sees himself at times. His work consists of walking, looking, and taking photographs. Armed with a pocket camera he meanders through cities, and by doing so he became one of Japan's most important photographers.

DAIDO MORIYAMA

1938 Born in Ikeda, Osaka, Japan

1955–58 Studied graphic design in Osaka

1965 Published first images in the magazine *Camera Mainichi*

1968 *Japan: A Photo Theater*

1972 *Farewell Photography* and *Hunter* were published; suffered a creative crisis accompanied by drug and alcohol problems

1975 Lecturer at the Tokyo Vocational School of Photography

1984 *Memories of a Dog*

2012 Infinity Award: Lifetime Achievement, International Center of Photography

www.moriyamadaido.com

Japan in the 1960s was caught between centuries-old tradition and the influence of the modern Western world, particularly of America. In times of change, it is typically the artists who respond to give transformation a face. Daido Moriyama was among a group of artists that dared to move in a new direction. In 1968, the avant-garde artists around the famous photographer Shomei Tomatsu (1930–2012), including Moriyama, founded the experimental magazine *Provoke* as a forum for alternative voices—and he would contribute to its second issue. Although only three issues were published, the magazine was highly influential and its manifesto would have far-reaching consequences. They declared that the photograph is not merely a visual sign testifying to the existence of the objects in front of the lens but also, and above all, a manner of conveying the experience of the moment. The conventions of photography were questioned, and the focused shifted to "grasping with our own eyes those fragments of reality far beyond the reach of preexisting language." And it was on the basis of these principles that Moriyama developed his personal style, saying, "For me, capturing what I feel with my body is more important than the technicalities of photography. If the image is shaking, it's OK, if it's out of focus, it's OK. Clarity isn't what photography is about." Neither were high contrast and grain a problem—in fact, the opposite was the case.

Particularly in a time of digital-technological perfection, Moriyama's images are as haunting and unusual as they were when he formed part of *Provoke,* albeit in a different way. In those days, technical precision was still an important criterion in photography. Moriyama's colleague Nobuyoshi Araki observed that photographers had previously been slaves to the camera and that Moriyama had set them free. With the theory that "the camera doesn't matter," Moriyama works almost exclusively with small compacts, once analog and now digital. Naturally this affects the result. With a compact camera one acts more freely, more spontaneously, and goes unnoticed. And while the picture quality is somewhat lower, this does not particularly matter much to Moriyama, quite the contrary. In many photographic works one finds technical perfection and digital precision but the sentiment often seems off. In photography, grain, contrast, depth of field, movement, and spontaneity are all means of expression. And just as in painting a sketch is often more direct and expressive than a museum-quality canvas, in photography the raw, messy, technically unpolished images are often those that leave a lasting impression on the viewer. It is Moriyama's immediacy and spontaneity, his emotional proximity to the images, that is expressed in his raw photography.

It is no coincidence that in the new millennium the works of Daido Moriyama are being rediscovered and celebrated throughout Europe and the United States. In 1994, Joel Meyerowitz published an influential book on street photography in which the Japanese photography of Moriyama and his brethren was noticeably absent. So what a wonderful thing that his work has finally found its deserved place.

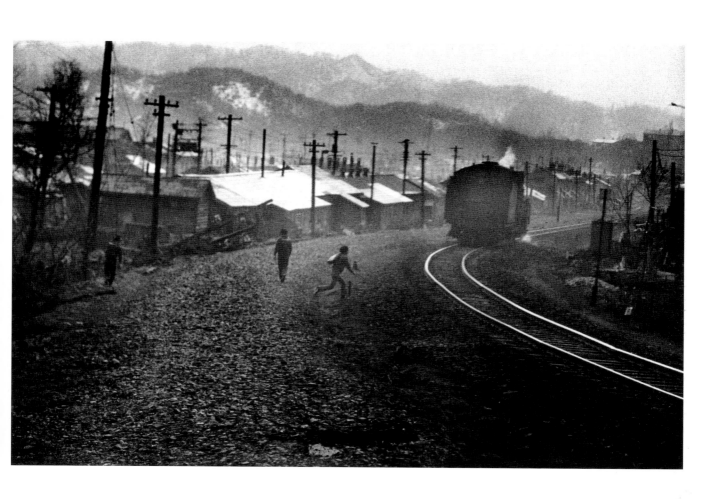

Grand Level, Yubari, 1973

WILLIAM EGGLESTON

American photographer William Eggleston brought a new quirkiness and sense of humor to documentary photography. Made in the late 1960s and 1970s, his early images of the rural South helped promote the use of color in art photos. Eggleston later documented the filmmaking process, photographing the sets of *Annie* and other well-known movies.

WILLIAM EGGLESTON

1939 Born in Memphis, Tennessee, USA

1965 Began to work with color negative film and chromogenic color prints

1974 Published his first portfolio, *14 Pictures*, from photos made with a dye-transfer process

1976 Major exhibition at the Museum of Modern Art in New York

1982 Photographed the set of the film *Annie*, the first of several commissions from movie directors

2004 Received the Getty Images Lifetime Achievement Award

When William Eggleston first gained national attention as a photographer in the late 1960s, critics were struck by the novelty of his images and the obscurity from which he came. Eggleston was born in the American South, and his development as an artist occurred largely in isolation. He began taking photographs as a teenager in the mid-1950s, inspired by the documentary photography of Henri Cartier-Bresson, who used energetic, asymmetrical compositions to capture the beauty of the fleeting moment. By the mid-1960s, Eggleston had also begun to experiment with color photos, a medium that had been largely dismissed as "vulgar" by earlier art photographers. He soon began producing images that art critics called "failed snapshots," where the human subjects were often captured obliquely and partly out of the frame. Yet, on closer inspection, the photographs revealed precisely thought-out compositions.

In 1967, Eggleston showed his work to curator John Szarkowski at the Museum of Modern Art. Szarkowski had been championing the work of young photographers, and he was amazed by what he saw. As Eggleston later recalled, "I made an appointment. I had a lot of prints, mostly black-and-white, some color. I dropped my pictures off, and when I came back a couple of days later, he told me he'd never seen anything like them before." The museum would purchase some of Eggleston's work, helping vault the young artist into prominence.

In the late 1960s and 1970s, Eggleston experimented with different ways of making color prints. These methods included the chromogenic process (or making prints directly from color negative film) as well as the dye-transfer process (or the transferring of color dyes by hand onto photo paper). Both methods enabled him to produce colors that were far richer and more vibrant than those in his earlier work. The example shown here, made around 1970, displays the chief characteristics of Eggleston's art. The carefully composed scene is given energy by vivid areas of color. Yet there is also an otherworldly, slightly humorous quality to the piece. Eggleston seems to be revealing the hidden oddities of "heartland" America. The image could also be compared to a dreamscape. Eggleston himself referred to his own dreams when he said, "But when I'm asleep, I'm in a world quite removed from me, with moving lights and perfectly contoured shapes." Eggleston's quirky, colorized view of America would inspire generations of artists that followed him.

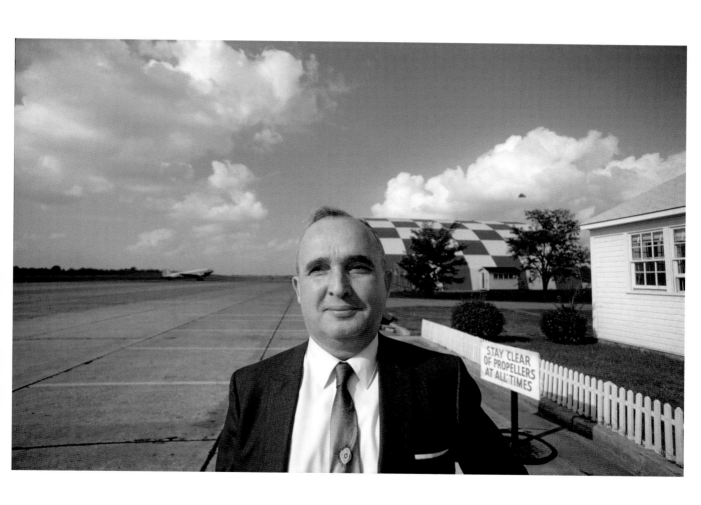

Untitled (Huntsville, Alabama), circa 1970

NOBUYOSHI ARAKI

"You have to go on photographing the moment of life; you have to go on living. For me, taking photos is life itself." The evidence that Nobuyoshi Araki has lived and continues to live intensely can be found in the more than 450 photo books he has published to date. In Japan, he is both an enfant terrible and a pop star.

NOBUYOSHI ARAKI

1940 Born in Tokyo, Japan

1959–63
 Studied photography and film-making at Chiba University, Tokyo

1965 First solo exhibition in Tokyo

1974 Cofounded the Photo Workshop School (until 1976) with Daido Moriyama and others

1990 Honored by the Photographic Society of Japan

1992 First solo exhibition in Europe (Graz), which later traveled to ten European cities

1994 First solo exhibition in the US

2008 Received the Austrian Decoration of Honor for Science and Art

www.arakinobuyoshi.com

Nobuyoshi Araki photographs virtually everything that appears in front of his camera: still lifes, flowers, architecture, sex, plastic dinosaurs, landscapes, animals, everyday life, unusual things, public things, private things—and very private things. In 1970, he achieved renown, or rather "notoriety," with close-ups of different vaginas, which he sent as photocopied books— *Xeroxed Photo Albums*—to friends, random strangers, and art critics. This established two of his work's main themes: women as his principal subject; and provocation, which he himself does not recognize as such—unlike the police, who have arrested him on several occasions for breaking obscenity laws. Like his colleague Daido Moriyama, Araki took photographs primarily in Shinjuku, home to Tokyo's entertainment district, and dealt extensively with every form of sexuality, both private and public, then practiced in the district. He became internationally renowned with his photos of bound women, a practice perceived differently in Japan than in either Europe or the United States. *Kinbaku*, a traditional form of erotic bondage, is regarded as an erotic art in Japan, and according to Araki it has nothing to do with the degradation of women: "I tie women's bodies up because I know their souls can't be tied. Only the physical self can be tied. Putting a rope round a woman is like putting an arm around her."

But Araki has another, melancholy side. A number of his series are dedicated to his wife Yoko. In 1971, he published *Sentimental Journey*, a photographic diary of their honeymoon that included intimate and tender private photos. In *Winter Journey* of 1991, he accompanied his wife through an illness until her death, and beyond. They are touching photographs of a sorrowful parting. Since Yoko's passing in 1990, death lingers as a prevailing mood in Araki's work, such as in his flower still lifes, which are almost like a memento mori. Eros and death are invariably connected and coexist in his images; for Araki, sex, unlike death, is not taboo: "To speak nowadays of real taboos means to speak of death." Despite, or perhaps because of this, Araki obsessively continues to take photographs, but without an obsessive concern for composition or technical quality. He photographs everything to which he "is related," as if he will only continue to live as long as he keeps pressing the shutter. For him, photography is "realization," even though he does not take himself particularly seriously: "I don't have anything to say. There's no special message in my photos. . . . I don't take photos to shove everything in everyone's face. . . . I have no special ideology, no ideas about art, no thoughts or philosophy. It's as though I'm just a little rogue getting up to mischief." This "rogue" wants the following sentence—which he un-doubtedly takes seriously—as his epitaph: "Photography is love and death."

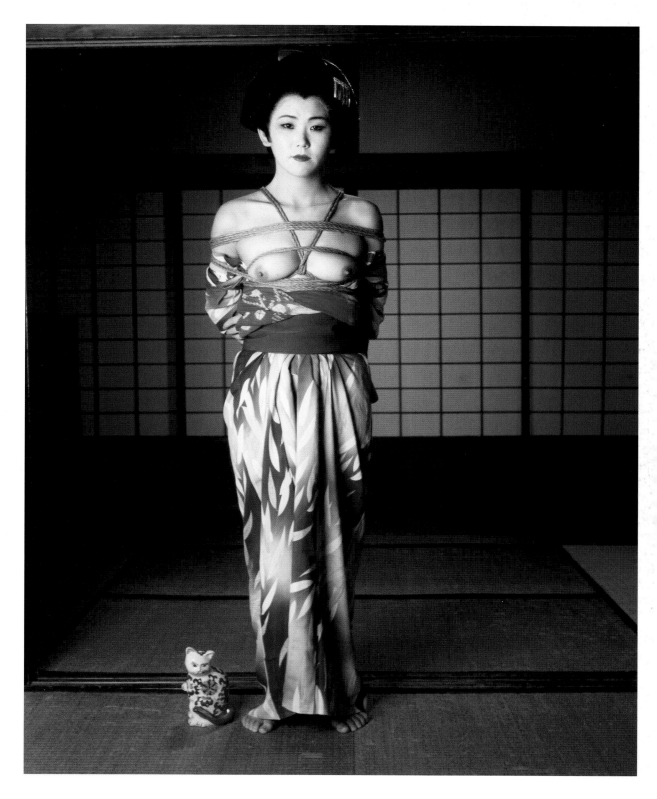

67 Shooting Back (GDN125), 2007

SARAH MOON

There are a number of female fashion models who switched sides and exchanged life in front of the camera for life behind it. The most famous in the documentary genre was Lee Miller (1907–1977). In fashion photography, it is Sarah Moon.

SARAH MOON

1941 Born Marielle Warin in Vernon, France

1960–66
Worked in London and Paris as a model under the name Marielle Hadengue and began to take photos

1970 Decided to focus entirely on photography and call herself Sarah Moon

Commissioned for photos and advertising films by prominent fashion houses and magazines

1979, 1986, 1987
Golden Lion for advertising films, Cannes Lions International Advertising Festival

1991 First feature film, *Mississippi One*

1995 Grand Prix national de la photographie

2008 Prix Nadar for *1 2 3 4 5*

Sarah Moon had revolutionized fashion photography so profoundly in the 1970s that the number of copycats has obscured her role as the true innovator. As with Nan Goldin's photos of her own private milieu that led to a flood of imitators, so it was the case with fashion photography after Moon. In contrast to the austere, icy beauties of a Helmut Newton, in Moon's images for famous fashion brands such as Cacharel and Chanel she revealed a new femininity, as playful as it was fragile. During the 1980s, she worked for Japanese designers, including Issey Miyake and Yoji Yamamoto, and changed her style. The images were minimalist, almost abstract; she highlighted more of the clothes' cut and construction and distanced herself from the then popular "cult of the model" exemplified by photographers like Peter Lindbergh and supermodels like Naomi Campbell.

Moon increasingly focused on her own artistic projects. In addition to her photography, she is also a filmmaker; she has made five shorts based on fairy tales, documentaries on photography, and a feature film, *Mississippi One* (1991). Her photographs are at times dreamlike; at other times they are oppressive and melancholic: "I continued along the 'road'—and the 'road' became darker." She shoots primarily in black and white and, in particular, with Polaroid, as long as the film stock is still available. Some of her images look like memories whose contours are starting to fade. The imperfection of the Polaroid process also adds to this impression, with the characteristic flaws and frayed edges evoking an appearance of impermanence. In an era of digital perfection, her photos seem all the more pictorial, not least because of her choice of motifs: architecture, flowers, and animals that seem to emerge from a sometimes unsettling, oppressive dream world. Moon has said, "My photos are fiction; they are not reality. But it is reality that influences me. So I cannot show this fiction as sweeter or more harmless that I experience it."

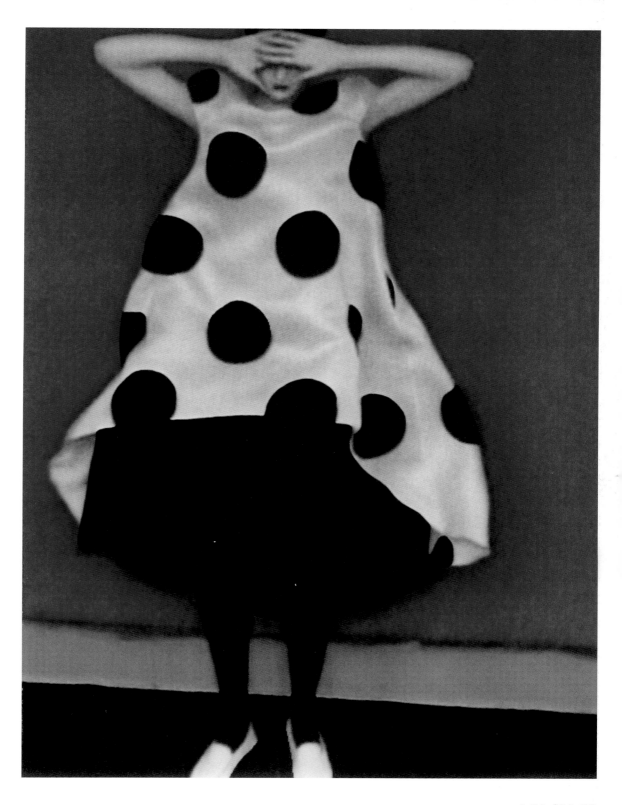

La Robe à Pois, 1996

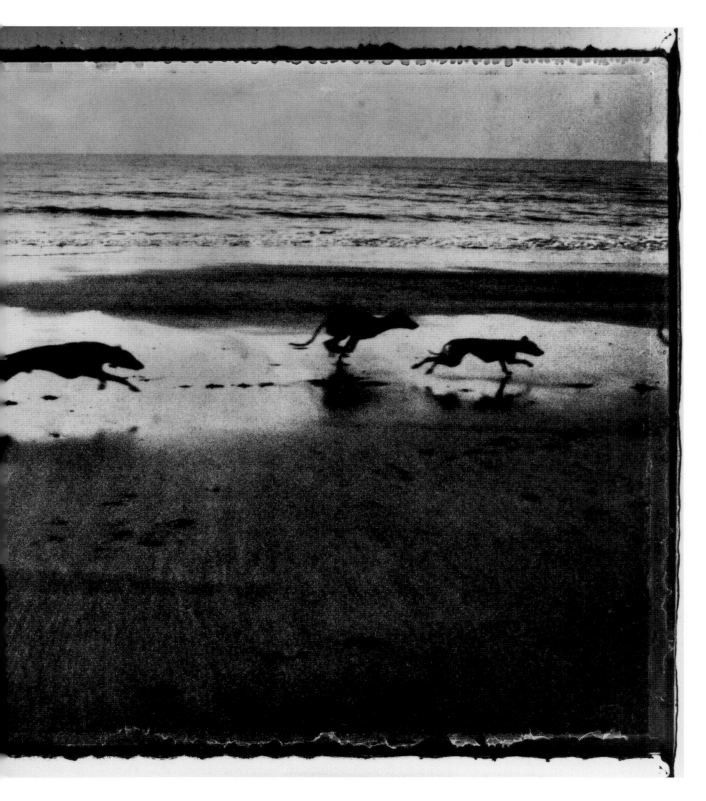

Maria's Dogs, 2000

09

CANDIDA HÖFER

For Candida Höfer, archi-
tectural interiors are the
vehicle to explore intan-
gible ideas. Her technically
precise imagery presents
well-known spaces in new
ways, often without people,
in order to invite the viewer
to contemplate their emo-
tional content and cultural
associations.

CANDIDA HÖFER

1944 Born in Eberswalde, Germany

1964–68
 Studied art and photography at
 the Cologne Werkschule

1973–82
 Studied film at the Kunst-
 akademie Düsseldorf

mid-1970s
 Began making her signature
 architectural photographs

1997–2000
 Taught at the Staatliche Hoch-
 schule für Gestaltung Karlsruhe

2002 Participated in Documenta 11

2003 Participated in the Venice
 Biennale (together with Martin
 Kippenberger)

2006 Solo exhibition at the Louvre,
 Paris

Since receiving her first camera as a teenager, Candida Höfer has spent her life exploring the ways photographs can capture space—and the meanings inherent in that space. She initially studied photography at Cologne's Werkschule in the 1960s. But it wasn't until she enrolled at the Kunstakademie Düsseldorf in 1973 that she began to develop her own style. At that time, Höfer developed an interest in Germany's Turkish communities, which led her to photograph Turkish family life in different German cities. Eventually, she began to focus on the interior spaces where these families lived rather than depicting the people themselves. These photos showed kitchens and living rooms filled with the objects of daily existence: empty tea glasses and posters of rural Turkey on the walls. They revealed a great deal about the lives of their inhabitants.

From 1976 to 1982, Höfer studied under Bernd Becher, who along with his wife, Hilla, had produced important photographs of Germany's architectural landscape—both its historic buildings and its industrial factories. Their images often featured towers, which were shot in a way that gave them an imposing, almost anthropomorphic presence. Höfer, inspired both by the Bechers' example and her Turkish experience, would soon make architectural interiors the main visual motif of her work. Yet the subject of Höfer's architectural photos is not the building itself but the space that it creates. As she has said, "I want to emphasize the things within that space: light, color, certain structures." Höfer is also interested in how an empty (or nearly empty) room can suggest the human activity within it. In *Deichmansk Bibliothek Oslo II 2000*, the artist does include a few human bodies in her image. Yet the overwhelming focus of the work is the vast space above them—a space framed by the rigidly angular columns and the idealistic mural depicting the virtues of knowledge, order, and industrial progress. Höfer's image suggests links between the traditional values of the mural and the classical symmetry of the space itself.

From the early to mid-1990s, Höfer's *Zoologische Gärten* photographs explored the relationship of "exhibited" animals with the artificial spaces designed to house them. The artist would also spend time teaching photography, and she served as professor at the Staatliche Hochschule für Gestaltung Karlsruhe from 1997 to 2000.

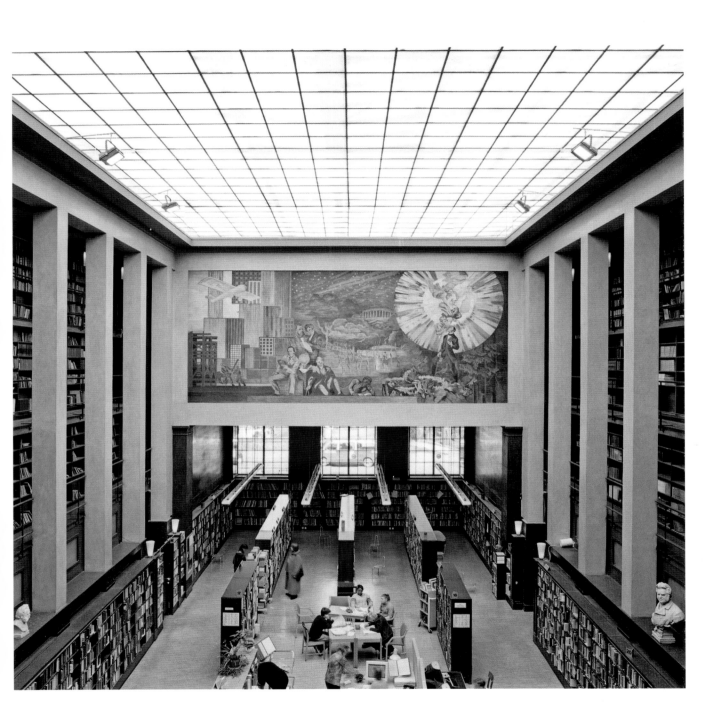

Deichmanske Bibliothek Oslo II 2000

10

SEBASTIÃO SALGADO

Sebastião Salgado is the great epic poet among contemporary photographers. Alongside his impressive and poignant black-and-white photographs, this singular artist has created monumental photographic cycles that represent the complexity of important global issues, such as hunger, work, war, and migration.

SEBASTIÃO SALGADO

1944 Born in Aimorés, Minas Gerais, Brazil
1963–67
 Studied economics in São Paulo
1969 Emigrated to Paris
1979–94
 Member of Magnum Photos
1993 *Workers* (book)
1998 Founded the environmental organization Instituto Terra
2000 *Migrations* (book)
2007 *Africa* (book)
2013 *Genesis* (book)
2014 *The Salt of the Earth*, directed by Wim Wenders
2015 *The Scent of a Dream* (book)
www.amazonasimages.com

A trained economist, Sebastião Salgado traveled the world on behalf of international organizations and began to look more deeply at the larger social and economic contexts. In 1971, he decided to become a photographer, with everything that entailed. "I put photography as my life. I lived totally inside photography."

Salgado shows in his images what people can do to people, and the impact of hatred, war, environmental destruction, and hunger. Robert Capa demanded that photographers get as close to the action as possible, and Salgado gets extremely close to his subjects, to people in need, physically and psychologically. The often-heard reproach about the aestheticization of human suffering for profit is far too short-sighted in Salgado's case, because in order for images to affect change they must be published and seen. And how better to achieve this than with photos that affect people? Salgado's talent lies in creating images that capture more than the moment but rather something universal. His photographs are, in the best sense of the word, sustainable, and have become part of our collective memory. Salgado has photographed the people of Latin America (1977–84), famine in the Sahel (1984–85), gold mining in Brazil (1986), burning oil fields in Kuwait (1991), and genocide in Rwanda (1994).

Rather than from assignment to assignment, Salgado works in large cycles in which he takes on controversial topics that drive the world. *Workers* (1986–93) illustrated the transformations taking place in the world of work in twenty-six countries on the threshold of the postindustrial age. In *Migrations* (1994–2000), he focused on the global refugee problem, which today, more than twenty years after he started, is more combustible than ever. After having documented the suffering in the world, he became ill, and this illness would lead to yet another cycle, *Genesis* (2004–12). Salgado captured nature as it is, before the destruction wrought by humanity, in places that are still largely untouched by the impact of the globalized world: "In *Genesis*, my camera allowed nature to speak to me. And it was my privilege to listen." While before he had engaged with only one of the world's species, humans, with *Genesis* he turned his lens to the others, in epic landscapes and haunting images of animals, hoping to preserve the Earth's last remaining unspoiled regions for future generations.

Genesis represented a break for Salgado not only in the choice of subject but also in his photographic process: he abandoned analog photography for digital. It had become too difficult for him to travel with hundreds of rolls of film, and he couldn't be sure that the enhanced X-rays at airports wouldn't destroy his work. As he found digital photography to be too flat, he only made the switch when it became possible to mimic the grain of Kodak Tri-X film digitally. "Photography is a language," according to Salgado, who is only too conscious of the aesthetic effect of his "language." It would be a shame if it were to become too flat simply because the technology has changed.

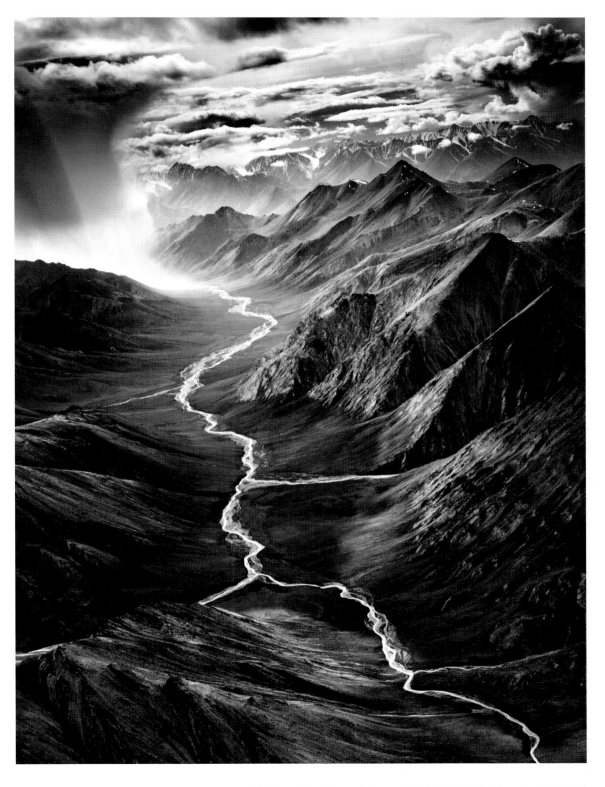

The Eastern Part of the Brooks Range, Arctic National Wildlife Refuge, Alaska, USA, 2009

TINA BARNEY

Tina Barney focuses her camera on an insular, privileged world. Using a technique that often involves complex staging, Barney is able to reveal the psychology of her wealthy sitters—and their milieu—in ways that only an "insider" can accomplish.

TINA BARNEY

1945 Born in New York City, USA

Mid-1970s
　　　Began taking large-scale photographs of her family and friends

1976–79
　　　Studied photography at the Sun Valley Center for Arts and Humanities in Ketchum, Idaho

1985 First solo exhibition in New York City

1988 Helped make the documentary film *Horst B. Horst*

1991 Received a John Simon Guggenheim Memorial Fellowship for photography

2010 Received the Lucie Award for Achievement in Portraiture

www.tinabarney.com

Portraits of the wealthy have been a staple theme in art for centuries. Yet few artists have possessed a more intimate understanding of the aristocratic life than Tina Barney. Born into the family that founded Lehman Brothers, the financial services company, Barney spent her youth among the social elite of New York City. Like many wealthy Americans of her generation, she studied art history as a teenager, traveled to Europe, and married in her early twenties. But it wasn't until the 1970s, when she moved to Sun City, Idaho, with her family, that Barney began considering a career in art. Believing that her life was on "autopilot," she went to the Sun Valley Center for Arts and Humanities, where she enrolled in photography classes. She soon began taking photos of herself, her family, and her friends. At first, these pictures were rather casual snapshots. But by the early 1980s, she was arranging her subjects in careful—and sometimes deliberately artificial—ways, often asking them to adopt specific poses. Rather than shoot in a studio, Barney preferred to work in her own home and the homes of her friends. There, she could capture her subjects within their own environment, using furnishings and other possessions as "characters" in the scene.

The images that came out of this process were a striking mix of the formal and the spontaneous. They also suggested the psychology of her sitters and of the world they inhabited. Barney's images quickly gained great acclaim, and she would eventually earn portrait commissions outside her own inner circle of friends. One of her more dramatic images, from 1998, depicts the art dealer Leo Castelli and his young wife. Here, husband and wife are placed slightly off center in their living room. They adopt gestures that seem to mimic the expensive artwork surrounding them: he resembling the image above the fireplace and she resembling the woman's head in the sculpture to the right. The artist's complex tableau reveals much about the ambitions of both her sitters.

Barney would also branch out into filmmaking, largely to explore her interest in the history of photography. She helped direct and produce films about the photographers Horst B. Horst and Jan Groover. However, she remains best known for her images that provide a unique glimpse into a world that most people never see.

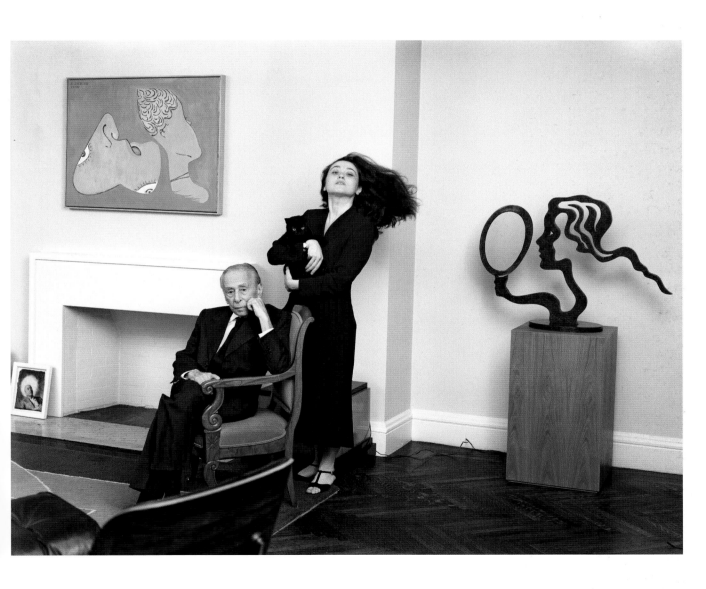

Mr. and Mrs. Leo Castelli, 1998

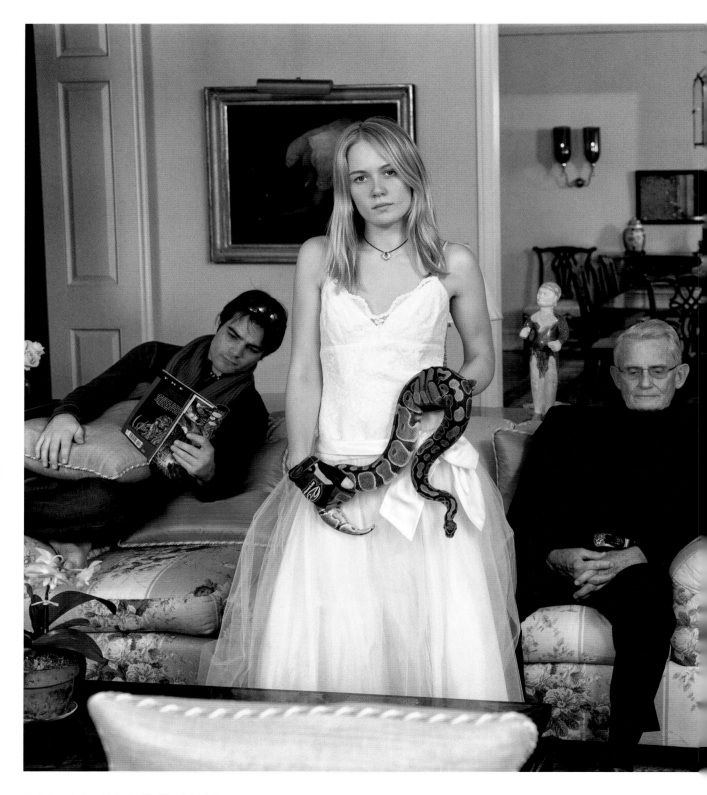

Family Commission with Snake (The Waterfalls), 2007

12

ELI REED

> "I had a lust to see and understand the world, how people endure what they have to endure. I wanted to see beyond the obvious." This curiosity was and is one of the more essential prerequisites that American photographer Eli Reed brings to his photography.

Eli Reed is one of the many renowned and respected photographers to arrive at photography in a roundabout way. He had in fact trained as an illustrator, but he soon turned to photography. It was the late 1960s, a time of race riots and the Civil Rights movement led by Martin Luther King, Jr. and Malcolm X, both of whom Reed sees as role models—not in photography but in life: "They inspired me to be the best in whatever I wanted to be." The subject of race has accompanied Reed his entire career. For his impressive book *Black in America*, he photographed and documented the African American experience from the 1970s to the 1990s. The book's publication in 1997 did not mean he left the subject behind: "Each picture that I take is a plea against racial prejudice. We are all sitting in the same boat. Of course I don't deny that racial differences exist. But I fight against every form of discrimination as hard as I can."

Reed saw the photographs dealing with issues of race in magazines like *Look* and *Life* and noticed that the best of them were invariably taken by photographers from Magnum. Reed himself was shooting for the *San Francisco Examiner* and in 1981–82 began to make a name for himself with his reports on Central America, even receiving a nomination for the Pulitzer Prize. In 1983, the esteemed photographer Philip Jones Griffiths, then president of Magnum, called Reed to ask how he could be convinced to join the agency. So Reed became not only the first photographer to join Magnum directly from a newspaper but also the first black photographer to work for the prestigious agency.

From then on, Reed, like all of his Magnum colleagues, traveled with camera at the ready to the world's important and dangerous flashpoints. From 1983 until 1987, he visited Beirut on repeated occasions to work on an ambitious, long-term study of the city, which became his first book, *Beirut: City of Regrets*. In 1986, he was in Haiti for the ousting of dictator "Baby Doc" Duvalier, and in 1989 he documented US Army operations in Panama. One of his primary concerns has been to show poverty and its crippling effects on people. In 1995, he participated in a Magnum book project on the subject of refugees, taking him to a camp in Tanzania where large numbers of Rwandan refugees were stranded. The body of images from his time there stands among his most powerful and poignant work.

Eli Reed is naturally aware that photographs do not bring about rapid change, but he still harbors the hope that they may cause something to stir in the longer term: "I believe when we address a problem, that's the first step to doing something about the problem. My photos are the way I do that."

James Carter Playing the Tenor Sax During the Filming of *Kansas City*, Kansas City, Missouri, USA, 1995

13

JEFF WALL

Canadian Jeff Wall's large-scale photo transparencies blur the boundaries between photography, film, advertising, and painting. They also helped spur an important regional art movement known as the Vancouver School.

JEFF WALL

1946 Born in Vancouver, Canada

1964–73
Studied art history at the University of British Columbia, Vancouver, and the Courtauld Institute, London

1976–87
Associate professor at Simon Fraser University in British Columbia

1977 Began working with photographic transparencies

1978 First solo exhibition in Vancouver that displayed a single work, *The Destroyed Room*

2002 Won the Hasselblad Award for photography

2007–08
Major retrospective exhibits in New York, Chicago, San Francisco, and Vancouver

"I remember being in a kind of crisis . . . and wondering what I would do. Just at that moment, I saw an illuminated sign somewhere, and it struck me very strongly that here was the perfect synthetic technology for me. It was not photography, it was not cinema, it was not painting, it was not propaganda, but it has strong associations with them all. It was something extremely open."

After many years of studying and experimenting with conceptual art, Jeff Wall decided to stop making artworks in the early 1970s. He needed to find a medium with which he could merge his own interests in modern popular culture, film, and the heritage of the Old Masters. Around 1977, he began exploring the possibilities of photo transparencies—or photographic images made on a transparent surface and displayed with backlighting. For Wall, this illuminated form of art seemed eminently modern. As he said, "In a luminescent picture the source of the image is hidden. . . . The site from which the image originates is always elsewhere. . . . To me, this experience of two places, two worlds, in one moment is a central form of the experience of modernity. It's an experience of dissociation, of alienation."

Wall's first major transparency, called *The Destroyed Room*, was exhibited at the Nova Gallery in Vancouver in 1978. The artist chose to place his work in the gallery's display window, enabling people to encounter the piece as both a work of art and a parody of illuminated "street advertising." The image itself showed a bedroom in complete disarray, with an overturned and torn mattress, clothes strewn on the floor, and a door ripped off its hinges. This deliberately chaotic scene suggested themes of modern urban decay, but its sophisticated composition also had a painterly quality. Wall's *Destroyed Room* would be the first of many transparencies that merged the commercial world and the world of art in new ways.

Another example of Wall's style, shown here, was produced from 1999 to 2000. It is based on a room described by African-American writer Ralph Ellison in the prologue of his novel *The Invisible Man* (1952). The narrator of the novel is shown sitting in his basement where "there are exactly 1,369 lights." Wall's image raises social concerns, such as alienation and racism, that cut across different generations in America. It also reveals the artist's flair for visual drama, with a grand tableau that resembles a movie set. Wall's pioneering work would influence a generation of artists in his home city of Vancouver, inspiring the Vancouver School movement.

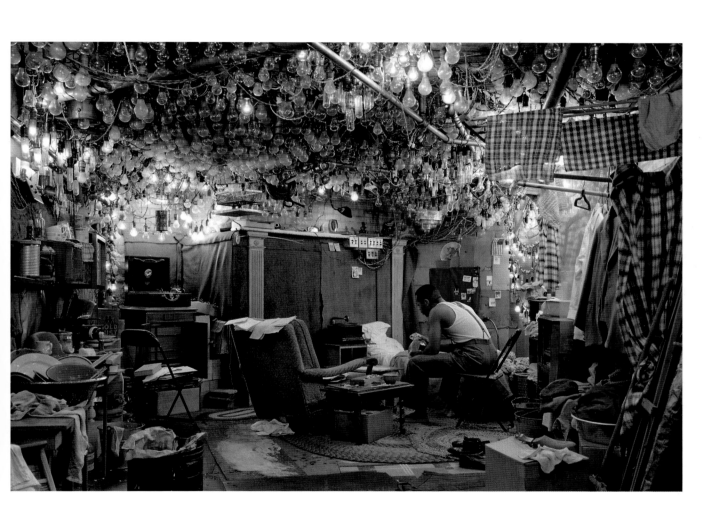

After *Invisible Man* by Ralph Ellison, the Prologue, 1999–2000

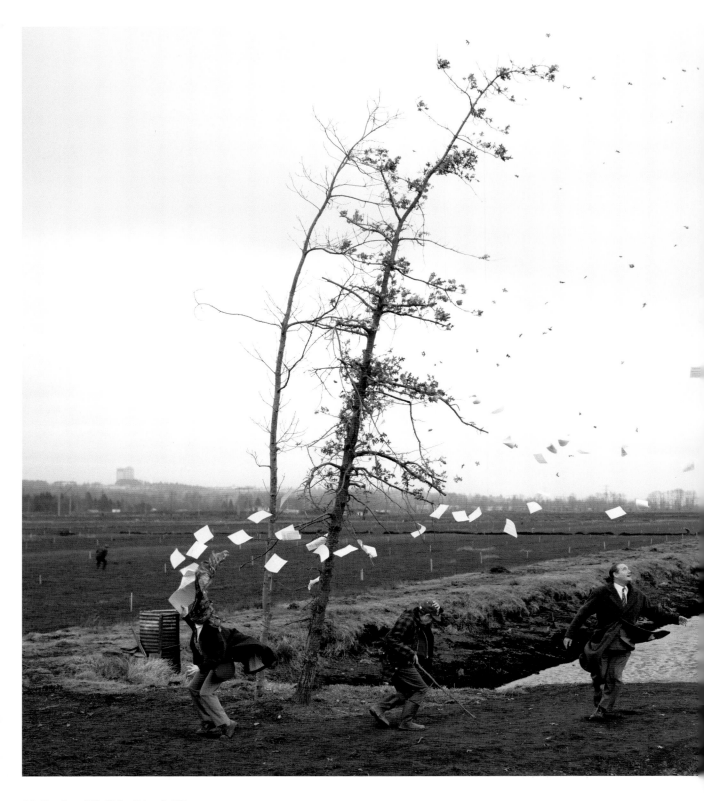

A Sudden Gust of Wind (after Hokusai), 1993

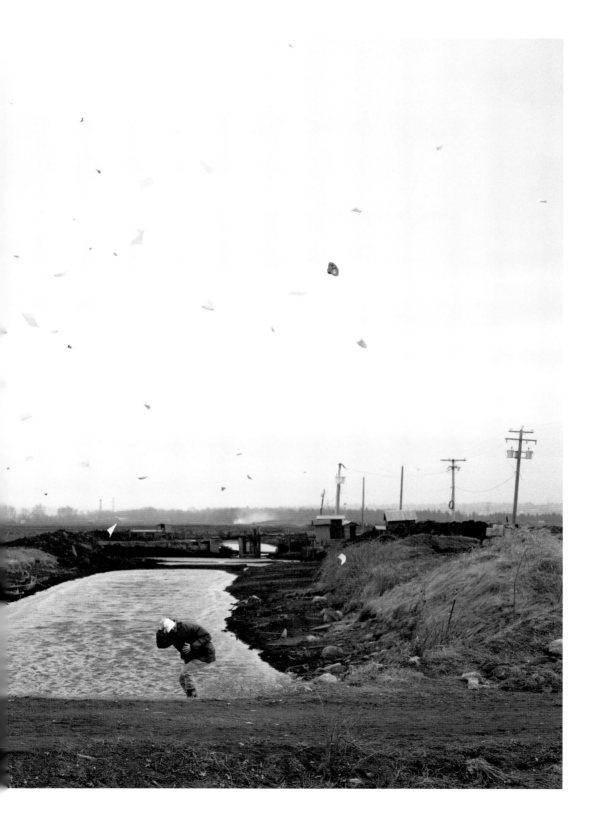

14 STEPHEN SHORE

After achieving teenage celebrity as a photographer in Andy Warhol's Factory studio, Stephen Shore left New York City for a voyage on the American road. There he made the vivid, richly colorful, and finely detailed images that would illustrate his groundbreaking book, *Uncommon Places*.

STEPHEN SHORE

1947 Born in New York City, USA

1965 Began working with Andy Warhol at his studio, the Factory

1971 Solo exhibition at the Metropolitan Museum of Art in New York

1972 Began taking his photographs of the rural North American roadside

1982 Published his book *Uncommon Places*

1982 Became director of the photography program at Bard College

2010 Honorary fellowship of the Royal Photographic Society

"Between 1973 and 1979 I made a series of trips across North America, photographing with a view camera. These were essentially journeys of exploration: exploring the changing culture of America and exploring how a photograph renders the segment of time and space in its scope. I chose a view camera because it describes the world with unparalleled precision; because the necessarily slow, deliberate working method it requires leads to conscious decision making; and because it's the photographic means of communicating what the world looks like in a state of heightened awareness."

As Stephen Shore writes in the 2003 edition of his seminal work, *Uncommon Places*, a photographer can reveal engaging details of the world that are either missed or improperly appreciated by other eyes. Unlike many photographers of his generation, Shore used on-the-job training—rather than a university program—to develop his art. While still a teenager, he was accepted into Andy Warhol's Factory, where he took portraits of studio luminaries. Warhol himself was fascinated by photography and other mechanical art-making processes, and Shore was inspired by the older artist's working methods. "I saw Andy making aesthetic decisions," Shore later recalled, "it wasn't anything he ever said to me. I saw these decisions happening over and over again. It awakened my sense of aesthetic thought."

Shore's early success earned him cultural grants from the National Endowment for the Arts and the John Simon Guggenheim Foundation to embark on an extensive new project. Carrying a bulky view camera with him, he went on a road tour of the US and Canada to capture scenes of rural life. The result was *Uncommon Places*. The vivid images in this book reveal Shore's keen sense of design and his eye for detail. One example, shown here, depicts a quiet street corner in Regina, Saskatchewan, a town in the middle of the Canadian prairie. This image combines the casual feeling of a snapshot with the timeless qualities of a painting. Shore achieves an elegant composition, featuring the sweeping rounded forms of the curb, the traffic light pole, and the buildings' arches. His camera also reveals the soft late-afternoon colors of the sky and the sunlit walls and street signs. These pictures would inspire the work of countless other photographers looking to explore their own ideas about color and form, tradition and modernity.

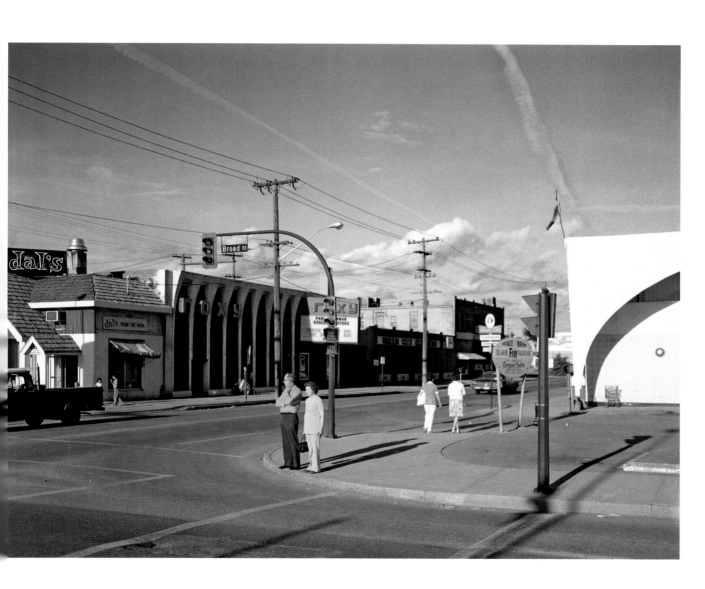

Broad Street, Regina, Saskatchewan, August 17, 1974

Amarillo, Texas, August 1973

Home of Tsal Groisman, Korsun, Ukraine, July 20, 2012

15

SUSAN MEISELAS

Photoreportage takes on many guises and there are numerous ways of addressing important, long-term subjects. American photographer Susan Meiselas uses photography as a culture of remembrance, bringing her back repeatedly to the places she has already worked.

Susan Meiselas first became known for her reporting from Central America during the 1970s. She documented the revolution in Nicaragua, when then President Somoza and his ruling clique were overthrown, creating iconic images of the conditions in the country, the opposition, and the rebels. A quarter of a century later she returned to Nicaragua to take part in commemorating the victory over the old regime, bringing with her mural-sized copies of her images that were placed at the sites where the photographs were originally taken. This gesture gave people an opportunity to revisit history, to remember the past, and to transmit a historical awareness to the young. It is this type of extensive inquiry that is so characteristic of Susan Meiselas's work. Not simply content with taking pictures, she is committed to the people she meets, returning to accompany them further through their lives. It is her nature and her sense of responsibility that goes far beyond the purely photographic: "The ethics of seeing are the ethics of caring. It's not a compositional issue only—to see. It's to feel, it's to connect, it's to engage in some way. Acknowledging the gift as a photographer of the encounter and the creation of a photograph."

At times, Susan Meiselas seems to be more a historian with a camera than a photojournalist. In 1991, she traveled to northern Iraq with Human Rights Watch, who were investigating the 1988 "Anfal" campaign against the Kurdish people. During her many trips to the region, Meiselas researched intensively to create a "Kurdistan archive" documenting the history of the Kurds through letters, historical photos, memories, and documents, which she presented in exhibitions, as a book, and as a website. More than simply memory, she is dedicated to using the evidence of the past to shape the present and the future. Meiselas works on projects for years, connecting them to people and communities in a very personal way. During a 2016 exhibition of her work in Frankfurt am Main, she organized workshops with refugees, with whom she worked to create memory books from mobile phone images and their personal experiences that she then integrated into the exhibition.

History unfortunately teaches us that many issues never change, that they are always with us, regardless of who holds the reins of power. The US-Mexico border is one such issue that Susan Meiselas has returned to repeatedly since her earliest days as a photojournalist. With the exception of the more technologically sophisticated methods of deterrence and surveillance, nothing much has really changed. The pressure and desire to cross the border in search of a better life are as strong as the pressure on the other side to prevent this from happening. It is a game of cat and mouse determined by economic, political, and social forces, and it is played out in constantly new ways. Susan Meiselas has documented the suffering of migrants long enough: "We see their eyes, but we don't know what their eyes have seen or what they see in us."

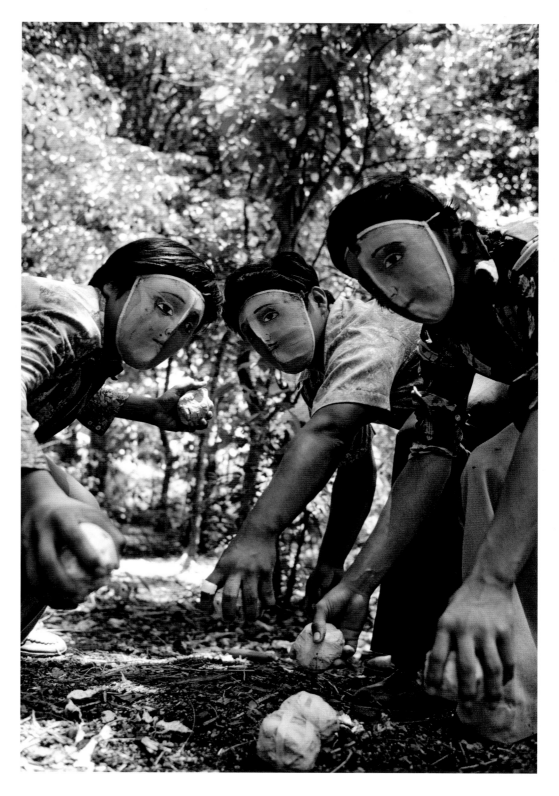

Youths Practice Throwing Contact Bombs in Forest Surrounding Monimbo, Nicaragua, June 1978

16 HIROSHI SUGIMOTO

Photographs of a Zen-like calm and meditative power coupled with graphic austerity: compared to Daido Moriyama or Nobuyoshi Araki, the work of Hiroshi Sugimoto reveals another, contemplative side of Japanese photography.

HIROSHI SUGIMOTO

1948 Born in Tokyo, Japan

Until 1970
 Studied politics and sociology in Tokyo

1974 Graduated from the Art Center College of Design, Los Angeles, and moves to New York

1976 Began the *Dioramas* and *Theaters* series

1977 First solo exhibition in Tokyo

1980 Began the *Seascapes* series

1988 Awarded the Mainichi Art Prize in Tokyo

1997 Began the series *Architecture* photographing prominent buildings out of focus yet still recognizable.

2001 Received the Hasselblad Foundation Award

2007–08
 Lightning Fields series

"As a medium, photography is interesting because it is young and therefore still has room to grow. . . . I've created a style in which I deliberately encroach on the field of contemporary art, a field that had previously remained untouched." And Hiroshi Sugimoto has tilled this field to great success. In 2009, he was even awarded the Praemium Imperiale, interestingly, for painting.

The power within Sugimoto's images reveals itself under sustained viewing; you must immerse yourself in them, just as Sugimoto immerses himself in his subjects. His photographs thus become meditations on time, the inexorable passing of which he makes visible, or perhaps only barely perceptible. We sense this in his famous series *Theaters* (from 1976), in which he photographed movie theaters using an exposure time equal to the duration of the film. An entire film in one photograph—rather abstract indeed; and though in the center of each image there is only a white screen, it is an enthralling mental experiment. Photography typically makes the transience of the moment visible by selecting and preserving a fraction of a moment from the flow of time. Sugimoto works in precisely the opposite way. As time is flowing through his pictures, the subject is duration.

In many of his photographic series, Sugimoto develops the main themes of time and history. One might well ask what is special about meticulously taken photographs of wax figures (1999) or capturing dioramas (1976–2012) from a natural history museum. But through photography, Sugimoto removes objects from their actual context and concentrates the gaze upon them. Observation is intensified and the illusion of reality created is reinforced through a reduction to black and white. The series *Seascapes* (from 1980), perhaps the most well known of his projects, is in some sense a distillation of his work: "Every time I view the sea, I feel a calming sense of security, as if visiting my ancestral home; I embark on a voyage of seeing." This voyage carries him to the horizons of the seven seas and other large bodies of water throughout the world. Light and air are condensed in the atmosphere and encounter the water; they are separated by the horizon line running through the exact center of each image, even if at times it is more felt than seen. If history and time are Sugimoto's main themes, the images of the sea are their essence. For they are the only landscapes that have not changed, that we still see exactly as our ancestors once did—a simple yet ponderable truth.

In 2007, Hiroshi Sugimoto photographed negatives by William Fox Talbot, one of the pioneers of photography and the inventor of the negative-positive process, making the images visible as positives for the first time in over 170 years. It is yet another example of Sugimoto's remarkable approach to time and history—and an homage to photography itself.

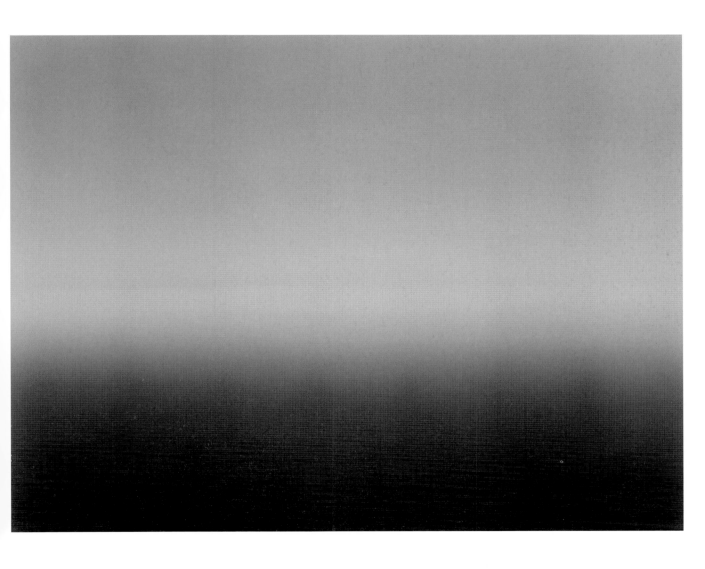

Ligurian Sea, Saviore, 1993

ANNIE LEIBOVITZ

Few woman photographers have created as many iconic photographs of pop culture figures as Annie Leibovitz, and few have achieved comparable fame. She photographs celebrities from the worlds of culture, sport, and politics for *Vanity Fair*, *Rolling Stone*, and *Vogue*.

ANNIE LEIBOVITZ

"She has photographed everyone who is anyone"—from the Rolling Stones, with whom she went on tour at the beginning of her career, to Bill and Hillary Clinton, Donald Trump, Barack Obama, Queen Elizabeth II, and John Lennon, whose portrait—his last—she took the day before he was killed. Annie Leibovitz has undeniably made her mark on twentieth-century celebrity photography. In the meantime, it is for magazines such as *Vogue* that, despite her typically astronomical fees, she offers access to celebrities who would probably not have time for less illustrious photographers.

It was at *Rolling Stone* magazine, where she was chief photographer from 1973 until 1981, that Leibovitz developed her concept of the narrative portrait after having previously worked with a white background in the style of Richard Avedon. The concept is in fact simple, and perhaps for that very reason so successful: for each shoot Leibovitz selects a theme connected to the star at that particular moment. She studies their work and develops her pictorial ideas from it: "Somewhere in the raw material was the nucleus of what the picture would become. It could be simple. There's a case to be made that the simpler the idea the better." This is how the iconic photos were created: Bette Midler on a bed of roses for her film *The Rose*; the Blues Brothers with their faces painted blue; and Whoopi Goldberg, who in her one-woman show played a girl who believed that underneath her black skin she was white, naked in a bath full of milk. One of her most poignant images was produced in collaboration with Keith Haring, who painted an entire room as well as himself in his signature style. Leibovitz's photographs are in no way antagonistic toward her famous subjects; she rather strengthens, emphasizes, or even creates an image that suits them and their work. Her apparent simplicity is successful because it reveals a facet of a person we believe we already know. Despite the effort that goes into them, the photographs are often simple, but they are never dull.

In 1991, one of Leibovitz's cover photos hit the headlines in a way that still amazes today: Demi Moore, seven months pregnant, "dressed" only in earrings and a massive diamond ring. Certain newsdealers in the US would only sell the magazine with a paper wrapper, while others refused to sell it at all. Leibovitz herself does not even consider the photo to be a particularly good one: "The cover is not a photograph. I mean you might as well be doing advertising; it really is designed to sell the magazine." Which is not to say that Leibovitz does not do advertising—she does. In addition to her work for magazines she shoots ad campaigns for large companies, for whom she has had tremendous success using her concept of narrative photography in increasingly elaborately staged images.

For years she has also been pursuing a project that she first developed with her late partner Susan Sontag (1933–2004), the first part of which was published in 1999 as a book with the simple title *Women*. In it she photographs prominent women from different professions and backgrounds.

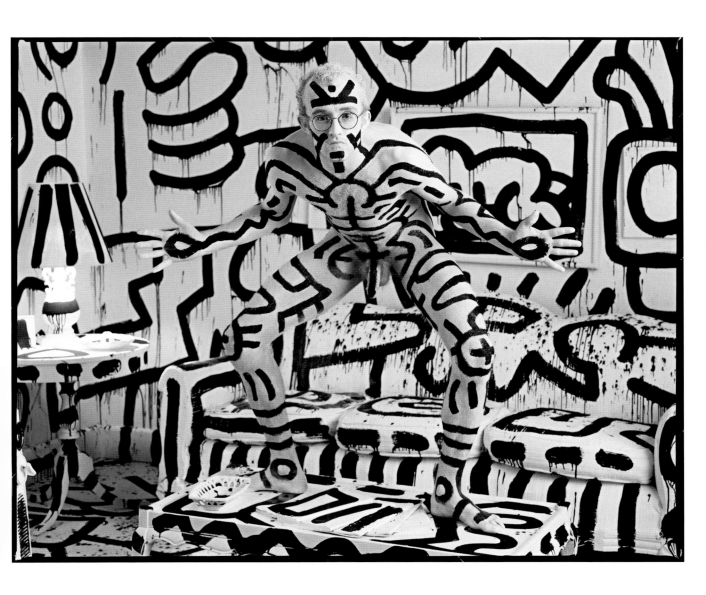

Keith Haring, 1986

18

ROGER BALLEN

Roger Ballen is a solitary figure in the worlds of photography and art. An American living in South Africa, he follows neither fashions nor dogmas, and he has developed his own style with a rarely seen independence and consistency.

ROGER BALLEN

As a photographer in South Africa under Apartheid, Roger Ballen did not photograph the separation between blacks and whites along with all the absurd implications of the inhumane system; he rather engaged in a long-term project in which his subjects were almost exclusively white. It was his specific subjects, however, that earned him a great deal of attention and even greater criticism, as he trained his lens on the white underclass that went largely unmentioned amid the propaganda of the "master race": the uneducated, poor, backward whites living in dirty, dilapidated housing were a taboo subject. The most famous of these photographs shows the twins Dresie and Casie, two dim-witted-looking men in filthy clothes, saliva running from the corners of their mouths down their shirtfronts. In 1994, Ballen published the book *Platteland*, which became an international success. In South Africa, however, the book provoked death threats, his arrest, and his expulsion from the artists' association.

In the years following, Ballen's pictures became more complex. Once depicting his subjects frontally and dominating the frame, in the series *Shadow Chamber* (2005), *Boarding House* (2009), and *Asylum of the Birds* (2014), Ballen now began to use them as figures within more complex still lifes in which pictorial and sculptural elements play an increasingly greater role. These different design approaches are connected by the photographic form: the square format and the consistent absence of color. These creative decisions give all of the elements in the image the same amount of space and possibilities of meaning. The pictures at times seem to be the product of psychoanalytic free association, by which one discovers the repressed or subconscious, something Ballen is increasingly interested in: "The older I get the more I need to get to the source . . . the source of the psyche."

The photos feel oppressive and claustrophobic; according to Ballen, their function is to confuse the mind. The discomfort they cause is intentional, but there also is something enigmatic, unexplained, that remains within viewers and takes root to trigger a journey into their own psyches: "When I create photographs, I often travel deep into my own interior place where dreams and many of my images originate. I see my photographs as mirrors, reflections, connecters that challenge the mind."

By integrating painting and sculpture, Ballen's images grow more multilayered and increasingly difficult to interpret. Unlike his earlier photographs, these works are no longer about people as individuals, but rather the figures and other pictorial elements in the complex compositions acquire a symbolic significance: "The photo is an abstraction of reality, which people should not confuse with reality itself." What is intentional, however, is the nightmarish effect—because the nightmare, Ballen says, "confronts us with truth; it does not play with us, but it conveys a message that might be significant. It is possible that it is not necessarily a good message, but it can be of great importance."

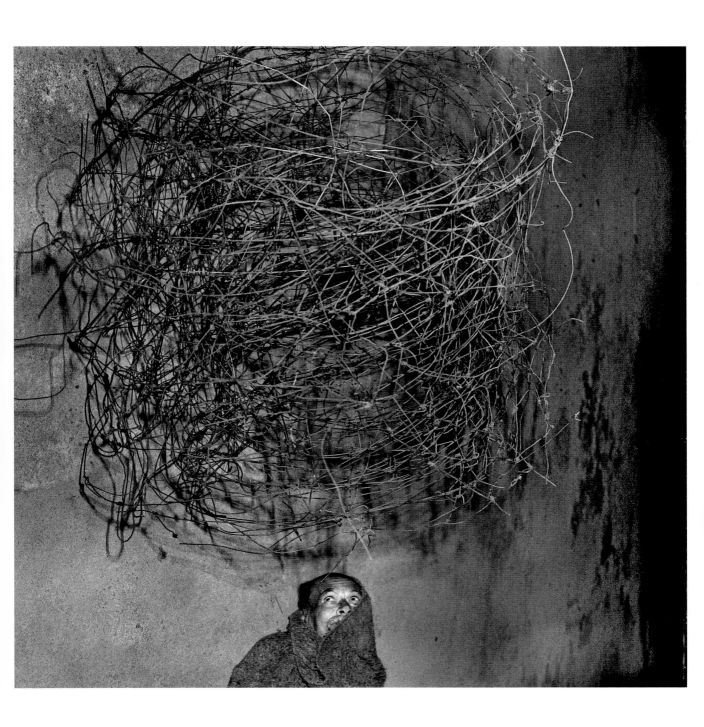

Twirling Wires (from "Shadow Chamber"), 2001

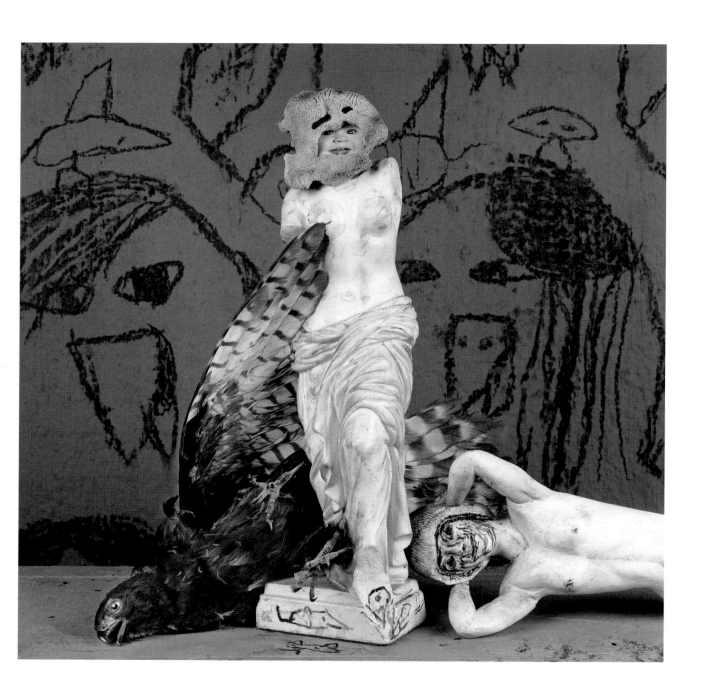

Fallen (from "Asylum of the Birds"), 2011

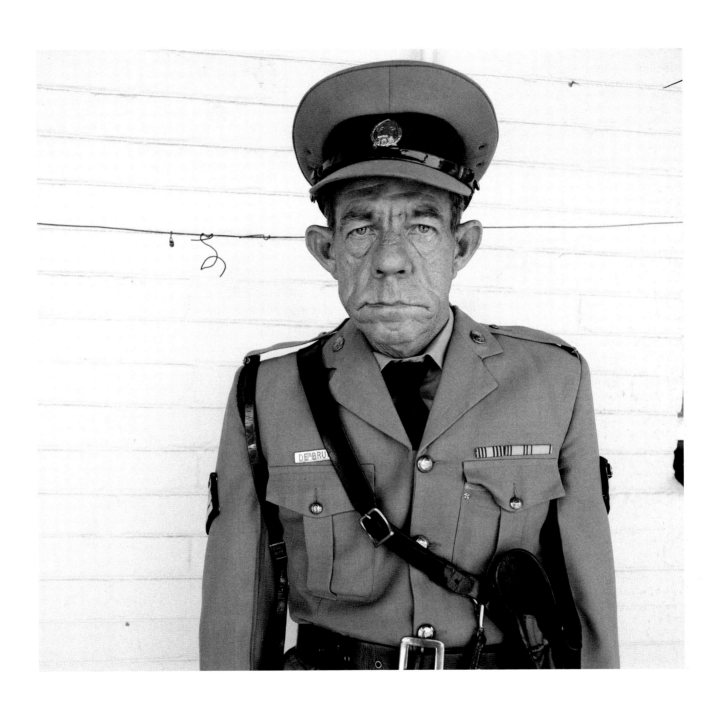

Sergeant F. de Bruin, Department of Prisons Employee, Orange Free State (from "Platteland"), 1992

19

STEVE MCCURRY

STEVE MCCURRY

1950 Born in Philadelphia, Pennsylvania, USA

1976 Studied film at Penn State University

1979 Traveled to India, Pakistan, and Afghanistan

1980 Robert Capa Gold Medal Award

1985 Won four first prizes in World Press Photo

1986 Made member of Magnum Photos

1992 Won two first prizes in World Press Photo

2005 Honorary fellowship of the Royal Photographic Society

His work appears in books, magazines, and newspapers worldwide

www.stevemccurry.com
www.magnumphotos.com

Kodachrome 64—for Steve McCurry that was the raw material of his work. The thirty-six frames on the final role meant the end of an era for the photographer: "I shot it for thirty years and I have several hundred thousand pictures on Kodachrome in my archive. I'm trying to shoot thirty-six pictures that act as some kind of wrap-up—to mark the passing of Kodachrome. It was a wonderful film."

Notwithstanding, Steve McCurry's first photographs to achieve recognition were in black and white. It was a reportage about the Mujahedeen, who resisted the Soviet troops after their 1979 invasion of Afghanistan. McCurry entered Afghanistan via Pakistan dressed as a local, at a time when there were virtually no Western journalists in the country. His pictures were among the first to be published on the subject, and they revealed certain traits that would later bring McCurry great renown as a photographer: he is in the middle of the action, and he is in close contact with the people he is portraying. His ability to quickly create a sense of trust and empathy undoubtedly helped. The hitherto unknown photographer had made a name for himself practically overnight, and the following year he won the prestigious Robert Capa Gold Medal for the best photographic reporting from abroad. And this was already in color, which would eventually become his inimitable trademark: the rich, oftentimes meticulously employed colors of Kodachrome.

"What is important to my work is the individual picture. I photograph stories on assignment, and of course they have to be put together coherently. But what matters most is that each picture stands on its own, with its own place and feeling." What is so special about McCurry's pictures? They are simply perfect: in composition, color, technique, and, above all, in the empathy for those in front of him that he is able to convey. It is this ability translated through his camera with which he succeeds in creating extraordinary portraits that remain in the viewer's mind. In 1984, when McCurry took one of the world's most famous images, the portrait of the "Afghan Girl," he had just two minutes and did not even know the name of the twelve-year-old girl who was gazing so intensely into his lens. It was not until 2002, when he and a team from *National Geographic* set off to find out what had become of one of the best-known faces in the world, that he, at last, learned the girl's name: Sharbat Gula.

Although McCurry has photographed numerous wars and conflicts—Afghanistan, the Gulf War, the Iran-Iraq War, to name but a few—it is the images from a more peaceful Asia that we have in our mind's eye when we think of that area of the world and this photographer. His photos are in some sense timeless, and have shaped the Western image of Asia without distortion. One can always photograph things differently because, as Émile Zola once said, "Art is Nature seen through a temperament"—and Steve McCurry indeed has a lyrical temperament.

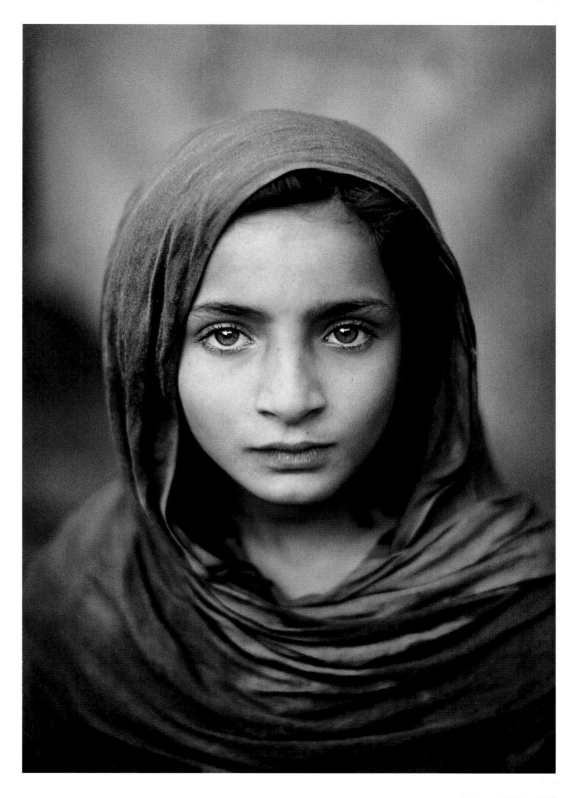

Peshawar, Pakistan, 2002

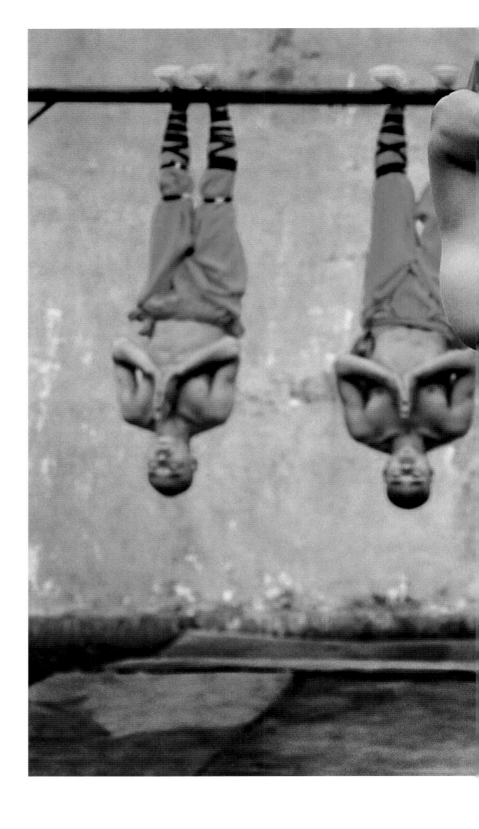

Shaolin Monks Training, Zhengzhou, China, 2004

PHILIP-LORCA DICORCIA

"I was never really particularly comfortable photographing people." This is certainly a surprising admission coming from American photographer Philip-Lorca diCorcia, since there are practically no photographs known to us taken by him in which people do not appear.

PHILIP-LORCA DICORCIA

Even in Philip-Lorca diCorcia's first photographic series people are the subject—the protagonists his friends and family who he exactingly placed in fictional situations and contexts but then photographed spontaneously, as if he randomly happened upon them. This combination of ostensible spontaneity and orchestration would appear in his later series, becoming, to a certain extent, one of his leitmotifs. In 1989, diCorcia was awarded a National Endowment for the Arts Fellowship that he used for the series *Hustlers* (1990–92), a decision which also represented a reaction to the difficult, often bigoted discussion surrounding AIDS—of which his brother had died—then taking place in the United States. DiCorcia traveled to Hollywood, where he asked male prostitutes to pose for his photos for the same amount they would normally receive for their services. Thus the somewhat curious titles: *Roy; "in his twenties"; Los Angeles, California; $50* or *Marilyn; 28 years old; Las Vegas, Nevada; $30* or *Brent Booth; 21 years old; Des Moines, Iowa; $30*. They list name, age, hometown, and the model's "fee." What is truly remarkable about diCorcia's images is the unusually sharp, almost metallic-looking lighting, which he achieves using multiple flash units. Some images are like modern versions of Edward Hopper's paintings, focused on the loneliness of people. But diCorcia does not concern himself with the personality of whomever is standing in front of the lens: "People represent things to me—they're not personal. Each person is a kind of archetype, which I manipulate to appear to be the archetype that I am thinking about, although most of the time they're not like that."

The leitmotif of loneliness, of an individual in his or her own universe, immersed in their own thoughts and secrets, appears to an even greater extent in diCorcia's best-known series, *Heads* (2000–02). The project featured different people walking through New York's Times Square, depicted as if detached from society. The lighting, somewhat reminiscent of the chiaroscuro of Caravaggio, was created by hanging remote-controlled flash units on scaffolding; then diCorcia, using a telephoto lens, photographed the people at the precise moment they reached a specific spot for which the light was set and the camera focused. Looking much like they had been shot in a studio, the photographs were taken with an analog medium-format camera, and diCorcia shot three thousand frames to arrive at the seventeen photographs finally chosen for the series. What he discovered in editing was not that we are all different but rather that we ultimately all resemble each other, which is why he selected those who seemed special, unusual. This series too was the result of spontaneity and orchestration, or as diCorcia expressed it, "It's very hard to get beyond a middle level: you can make an adequate image, but the ones that are special, those are the grace of god things, for which I say, thank you."

Head #10, 2002

SALLY MANN

Sally Mann became famous for photographs of her children. And though they depict an idyllic childhood, that the children are at times naked was a source of great controversy. But this is only one side of one of the United States' most successful photographer.

SALLY MANN

www.sallymann.com

The images of her children that placed Sally Mann in the spotlight were taken primarily at her family's summer home in the Shenandoah Valley, in Virginia. At first glance, they appear to be typical snapshots of a carefree childhood, and to a certain extent they are. But they are also staged compositions captured by Mann with an 8×10 camera, a tool that makes a spontaneous snapshot nearly impossible. Her use of the large-format camera and a lens with a long focal length give the images a very particular air: the soft focus in the background and a strong, almost palpable presence of the children in the foreground. Anything that might disturb or trouble the children was removed: "Perhaps I am creating my own childhood, as I would have liked it to be; or perhaps I am searching for my lost time." Mann indeed seems to have staged an arcadian childhood as Nicolas Poussin might have painted it—if he had painted in black and white with children as his subject. It is a childhood as an idealized time of innocence: free, happy, confident, and sometimes unclothed. And it was this last aspect for which Sally Mann was criticized, even accused of child pornography, and it raised a debate about whether the photographs should even be published. In 1990, the *Wall Street Journal* printed an image of four-year-old Virginia with black bars over her genitals and eyes, and the acclaimed *Artforum* refused to publish it. It is difficult to say whether the reaction was due to a genuine concern for the children or to a general prudishness in the United States. "I like to make people a little uncomfortable. It encourages them to examine who they are and why they think the way they do."

And indeed Sally Mann does cause discomfort, particularly with images that focus on death, which as a natural part of life has invariably fascinated her: "My work feeds on fear and terror." It is a terror that can be sensed by viewers in her series *Body Farm* (2000–01). Mann photographed decomposing corpses at a notorious testing facility near Knoxville, Tennessee, where scientists study the decay and postmortem changes of the human body. To avoid an extreme exaggeration of the terror, and to capture the transience of life, she used the wet collodion process, a technique dating from 1851. In this process, a glass plate is coated with wet collodion and then sensitized in a bath of silver nitrate before the picture is taken, after which the plate has to be developed immediately. Though significantly more costly and complex than digital photography, it produces spectacularly idiosyncratic images with a very particular radiance. Mann also used this technique for her series *Deep South*, in which she explored the landscapes of the American South and its mysteries and complexity. She has it said it is one of her favorite bodies of work. The project also examines issues that reach deep into the region's history—slavery and the Civil War: "When you drive through the South, you cannot help but realize that it would not be the way it is now if it hadn't been for hundreds of thousands of slaves who suffered and died on this land."

From "Body Farm," 2001–02

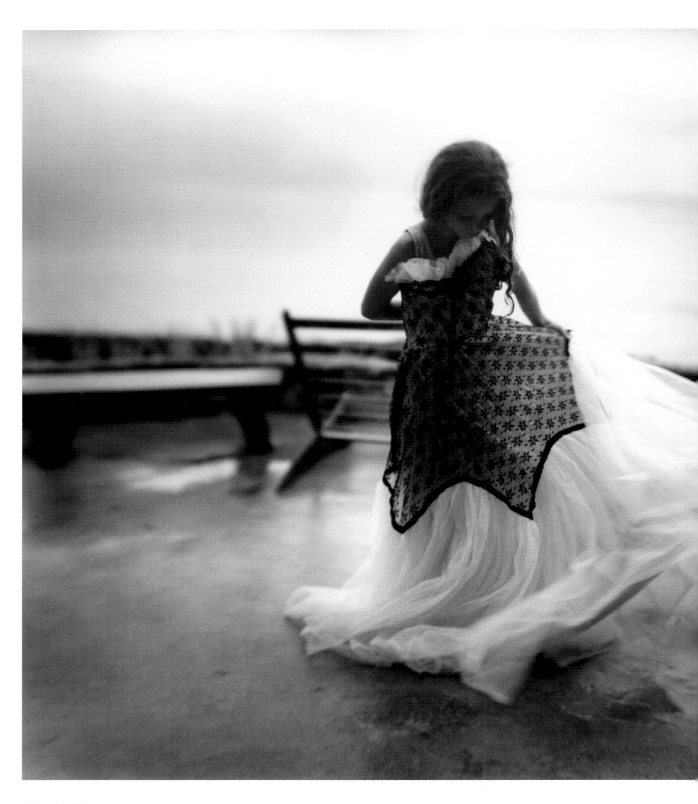

Virginia at 9, 1994

MARTIN PARR

Martin Parr reveals to us the world as it is and not as it appears in the glamorized advertising propaganda and photoshopped images of glossy magazines. This discrepancy between the world of advertising and the real world around us is the photographer's playground.

MARTIN PARR

1952 Born in Epsom, Surrey, England

1970–73
 Studied photography at Manchester Polytechnic

Since 1975
 Has taught at, among others, the National College of Art and Design, Dublin, and the University of Industrial Arts Helsinki

1982 *Bad Weather* (black and white)

1986 *The Last Resort*

1999 *Common Sense*

2004 Artistic director of Les Rencontres d'Arles

2004–14
 The Photobook: A History, 3 vols. (with Gerry Badger)

2010 Guest curator at the Brighton Photo Biennial

www.martinparr.com
www.magnumphotos.com

"A lot of my colleagues are attracted to war. But I'm drawn by the local supermarket round the corner, because I want to show the reality there. I don't want only the Third World to be documented, but also the First World." Martin Parr photographs normal, everyday life, and he does so more directly and bluntly than any photographer that preceded him. His pictures are revealing and sardonic. He has captured a family on the beach under an earthmover, young people in a fish and chip shop, traditional British food, clumsily dressed tourists, jetsetters with minor blemishes, crowds of tourists. He observes keenly, and when things turn awkward or bizarre he presses the shutter. And yet his photographs are neither defamatory nor venomous but rather spiced with British humor.

Before Martin Parr joined Magnum in 1994, there was a fierce debate about whether "such a photographer" was worthy of the agency of Henri Cartier-Bresson and Robert Capa. Some members felt that with his amateur-looking images he did not take photography seriously enough. He was voted in by only the slightest of margins, but Magnum had taken an important step forward—toward color and a new era of photographic expression and social critique. And that is what Parr attempts to achieve in his photos, but in his own way: "My approach is to criticize the conditions in the First World, what we are doing with mass tourism, the greenhouse effect, the lack of sustainability in our way of life, and so on. Those are my issues, but I package them in an entertaining way. Because if serious issues are only presented seriously, they achieve nothing, because no one wants to know about it." Parr does not photograph the exotic but rather the banal of the everyday, in all its outlandishness. Yet he does not beautify when he sees: "I always wanted to show things as I find them, not as we imagine them. Why should I lie?" They are the things we like to filter out of our everyday lives: inconsistencies both small and large, embarrassing outfits, or the most seemingly ordinary of things, such as mass phenomena or food. For years Parr has been using the same, simple technique: a macro lens and a (ring) flash. When he was still shooting analog, he used amateur films because the colors were brighter.

Like many photographers, Parr also questions his medium, albeit in his own particular way. In the series *Bored Couples* (1993), he shows couples that appear to have nothing left to say to each other. But this interpretation is a trap, because of course even the most animated conversation can contain such a moment, when it seems as if the participants have run out of things to say. It is a typical hint from Parr that we should not believe everything we see in photography. In support of his thesis, he and his wife are among the "bored couples."

Martin Parr is a collector. He is a collector of his own observations, which he captures in his photography (he has already published over ninety books); he is a collector of photo books (to which he has already devoted three volumes); he is a collector of kitschy knickknacks from around the world. He is one of the most influential photographers of our time and, despite initial disagreements, one of the most important additions to Magnum—and since 2014 its president.

GB. England. Ascot. From "Luxury," 2003

23

ALEX WEBB

When American photographer Alex Webb suddenly felt that he had reached a dead end with black-and-white photography, he switched to color, and has since become one of the most fascinating photographers working in color today.

ALEX WEBB

In 1976, Alex Webb, who became an associate member of Magnum that year, photographed small-town life in the American South in black and white, as was customary in those days. Magnum photographers were, in no small measure due to the agency's founders Henri Cartier-Bresson and Robert Capa, particularly ardent champions of black and white—even though Cartier-Bresson himself shot certain assignments in color. But also highly influential at that time was the black-and-white work of Lee Friedlander and Garry Winogrand. Thus color was still looked down upon in both documentary and art photography.

But it was in 1976 that Alex Webb, on assignment in Haiti and Mexico, realized what had led him to an impasse: black and white could not adequately capture the impressions left on him by the expressively colorful cultures of the Caribbean and Mexico. He could not do justice to the intense light and brilliant colors with traditional black and white, and in 1978 he switched to color photography. Since then he has created one of the most impressive and complex bodies of work in the field of color photography. Webb's work is elevated by an ability to capture rich, deep, luminous colors and sharp contrasts, along with his pastel tones and gentle moods. He combines this in his images with a compositional density and depth that he often enhances by using perspectives through doors and windows and a frequent use of mirrors.

Webb's first important monograph, the 1986 *Hot Light / Half-Made Worlds*, featured images from Africa, Mexico, Asia, and the Caribbean. Not merely a departure for Magnum, the book was widely seen as a pioneering work. What Joel Meyerowitz had achieved with his New York street photography, Alex Webb did in reportage: color became the decisive means of expression. It was followed by other photo books, which included *Under a Grudging Sun: Photographs from Haiti Libéré 1986–1988*, about Haiti after the fall of dictator "Baby Doc" Duvalier, and *From the Sunshine State: Photographs of Florida* (1996). Between 1998 and 2005, Webb traveled repeatedly to Istanbul and created what he himself described as his "most consistently visually complex work . . . because Istanbul is such a richly multilayered city." And it was precisely the diversity of the culture, architecture, and history that accommodated Webb's manner of creating images.

But even the grand master of color at times returns to black and white. For the book *Memory City* (2014), about the town of Rochester, New York, the home of Kodak, which he created together with his wife Rebecca Norris Webb, he used his last roles of Kodachrome, although they could only be developed in black and white. "It seems appropriate for this project that explores Rochester and something about memory, time, and the possible disappearance of film," Webb commented with a nostalgia understandable in a photographer.

Bombay, India, 1982

24 SOPHIE CALLE

Sophie Calle is one of the most famous French artists and, since the 1990s, has been a pioneering figure in conceptual art. Included along with the texts and installations of her artworks, which invariably deal with life, love, and death, is photography—serving as a kind of "evidence."

SOPHIE CALLE

The American writer Paul Auster, who based the character Maria in his 1992 novel *Leviathan* on Sophie Calle, said, "She writes and photographs, but she is not a writer and not a photographer." This characterization is accurate in its very vagueness. When Calle returned to her hometown of Paris after several years of traveling the world, she began her artistic projects, with one project leading to the next. First, in order to rediscover Paris, she followed strangers through the city and documented with a pen and camera several moments in their lives. Thus began the manner by which she rose to fame and became a pioneer of conceptual art: she staged a game whose rules she set both for herself and the other people, who knew nothing about it. They are short excerpts from the lives of others, or from her own, from which she creates art—projects with a certain voyeuristic approach. Calle follows, accompanies, and documents for a certain period of time the life of another who was at a particular place at a particular time. In addition to her written notes, she uses photography as "evidence," thus employing the medium in one of its original roles and possibilities: recording what is.

One generally assumes that a photograph is showing what actually happened and what was in front of the lens. One ascribes to photography greater credibility than one would, for example, to a drawing of the same scene. And so Calle would "pursue," for example, a fleeting acquaintance to Venice without his or her knowledge and photograph and document their stay as a detective would (*Suite vénitienne*, 1980). Since the hotel was a boundary she could not pass, a year later she got a job as a chambermaid in a Venetian hotel and photographed the luggage and belongings guests left in the rooms (*The Hotel*, 1981). There is invariably a revealing of the private, the visualizing of the unseen, whether it is of an other—or of oneself. In the project *The Shadow* (1981), she had herself tailed by a detective hired by her mother. She then juxtaposed the detective's professional research—consisting of text and photography—with her own observations and records of the same day. Calle also had a friend observe the detective.

Sophie Calle's work involves the interplay of truth and fiction, appearance and reality: "You take a bit of truth and you work with it. Things become fiction, because I try to make from it a document." Her mother once told her, "You have led people marvelously around by their nose."

From "Suite vénitienne," 1980

From "The Shadow," 1981

From "The Shadow," 1981

25 NAN GOLDIN

In order to fully comprehend the tremendous shockwave produced in the world of photography by Nan Goldin's work, we need to think back to the 1980s: pop culture, yuppie chic, aerobics, the stock market boom, and mainly black-and-white art photography.

NAN GOLDIN

1953 Born in Washington, D.C., USA

1973 First solo exhibition, Boston

1974–78
Studied at the School of the Museum of Fine Arts, Boston

1982 Various trips to Berlin

1986 *The Ballad of Sexual Dependency* published as a book

1993 *The Other Side*

2003 *Lucifer's Garden*

2009 Guest curator of the Les Rencontres d'Arles

2014 *Eden and After*

Lives and works in New York, Paris, and Berlin

www.matthewmarks.com

In 1986, when Nan Goldin published her book *The Ballad of Sexual Dependency*, it landed like a bomb. Even before publication, when she would show the images in a constantly changing slide show accompanied by music in New York clubs, they caused a stir. At the time, famous photographers reported on distant, exotic lands. Goldin's photos were created at home, in her own environment. She didn't want to photograph distant worlds, but her own, in order to tell the story of her own life. And that life took place within the New York subculture of homosexuals, drag queens, and junkies; it was a life of alcohol, sex, and drugs. For many viewers, however, this was in fact a remote, exotic world, out among the fringes of society. Nan Goldin and her friends did not, however, see themselves as such: "There is a misunderstanding that my work is about marginalized people. But we were never marginalized, because we were the world. We didn't care what straight people thought of us."

Goldin reveals the most intimate moments of her life and that of her friends, or, as she calls them, her surrogate family. She unsparingly photographs them in extremely private situations, like having sex or taking drugs. Nor does she spare herself. Far from being a voyeur, she herself is part of the action. In what became an iconic image, she shot a self-portrait with her then boyfriend Brian, sitting on the edge of the bed after sex, smoking a cigarette. What is she thinking? Is she in love? Months later she created another truly impacting image, after Brian had beaten her up, with bruises on her face and swollen bloodshot eyes. As Goldin has explained, "I do not take the pictures I have in my head; I experience things, and they become pictures." She is not interested in "beautiful" images. Goldin photographs directly, with flash, raw but at the same time intimate and full of feeling—and above all in color, which at the time was by no means common. In contrast to the somewhat abstract nature of black and white, color presents a reality in which nothing is glossed over, an unadorned and unsparing reality that exposes people's flaws.

Goldin's photography, of which there were few precedents but many imitators, can undoubtedly be regarded as a turning point in the history of photography. Her images are confessional, her private and personal attempt to survive and to consciously remember her friends: "I had to take pictures to stay alive." With her trashy visual aesthetic, Goldin had found a new form of expression. We are looking at a diary in which she reveals her most intimate moments and of those around her. And yet her photography is in no way voyeuristic, nor is it for voyeurs. Much of what her emulators produce, however, is a kind of fashionable junky kitsch that, paired with a voyeuristic curiosity or limited photographic skills, threatens to dishonor the manner by which Goldin reports on the world.

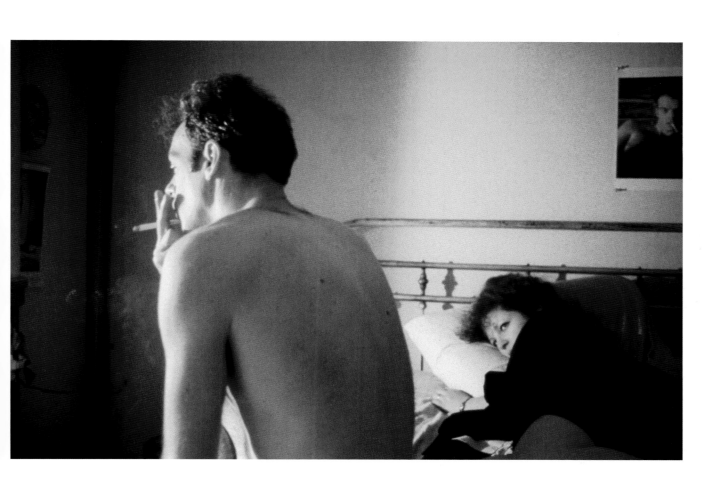

Nan and Brian in Bed, New York City, 1983

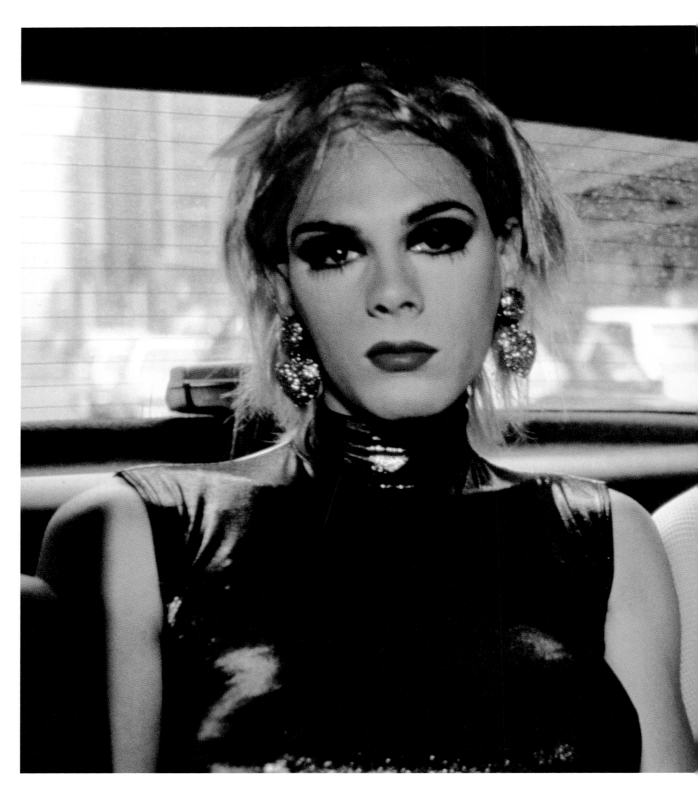

Misty and Jimmy Paulette in a Taxi, New York City, USA , 1991

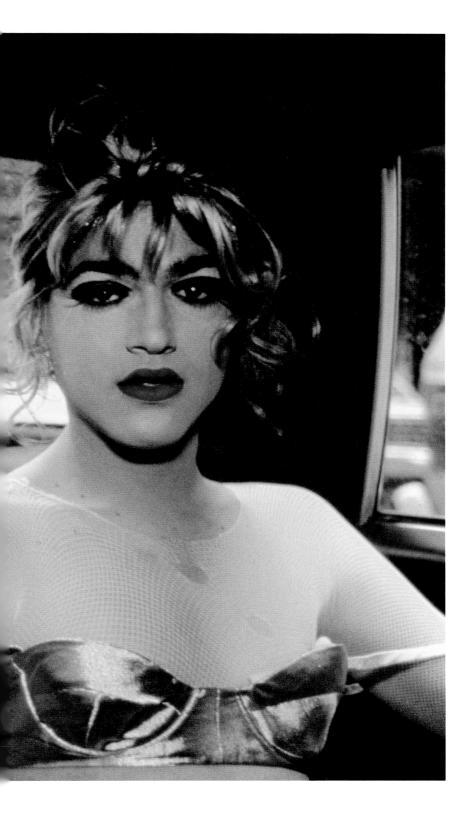

26

MICHAEL KENNA

Michael Kenna seems to be the calming influence in contemporary photography. With tremendous consistency and dedication, he creates black-and-white "photographics," landscape images, whose magic is ever more enchanting the longer you gaze at these relatively small works of art.

MICHAEL KENNA

1953 Born in Widnes, Lancashire, England

1972–73
Banbury School of Art, Oxfordshire

1973–76
London College of Printing

1977 Moved to the United States; worked as a commercial photographer, photo assistant, and b&w printer in San Francisco

1981 First successful exhibition in San Francisco

Until 1991
Advertising assignments for Rolls-Royce, Mercedes-Benz, British Railroad, among others

2000 Chevalier de l'Ordre des Arts et des Lettres

Lives in Seattle

www.michaelkenna.net

Michael Kenna is the best-known and most successful landscape photographer since Ansel Adams. He is consistent in his means of photographic expression—Hasselblad, black-and-white film, and classic prints that he develops in his own darkroom in an almost intimate format, which is a welcome contrast to today's modern, colorful museum photography. Kenna first became known with nighttime scenes for which he would sometimes use exposures lasting several hours. He enjoys sitting quietly beside his camera and just waiting. Perhaps that is what gives his photos their meditative power, the quiet and concentration transferred to the images and thus to the viewer. Perhaps it is, as Kenna says, "the feeling that there is something out there that we can't see, faith or something. . . . I know there is something else than the physical objects that I photograph."

Since Kenna has found his path, he has followed it consistently and successfully. He photographs all over the world—not only landscapes but also monasteries, industrial plants, or the remains of former Nazi concentration camps. But he is partial to the Japanese landscape. As he explains, "Japan lives within me. When I am not there, I think about when I will return." And because he often shoots there, one could see his images as a form of photographic haiku, for their highly concentrated expressiveness and the manner by which the viewer is led to the very essence. Kenna has been greatly influenced by Japanese art and, as he himself admits, his images recall Japanese ink drawings: "I look for graphic shapes, I look for simplicity of line, I look for an almost two-dimensional canvas with brush marks on it."

As with many photographers who still shoot analog, Kenna finds a special charm in the unpredictability of the results. Particularly in the extremely long exposures that bring things out into the light of day—or rather night—that cannot be seen with the naked eye. Water becomes a uniform surface, clouds are swept into unpredictable forms by the wind, and hardly perceptible light sources illuminate the scenery from different directions. But for Kenna, "Perhaps most intriguing of all is that it is possible to photograph what is impossible for the human eye to see—cumulative time."

Alongside the meditative calm radiating from his images, Michael Kenna also has an extremely active side that one would scarcely suspect from looking at his photography. In addition to the approximately four hundred exhibitions worldwide and a great number of books, he has also run more than fifty marathons. Perhaps that is the appropriate balance to so much tranquility.

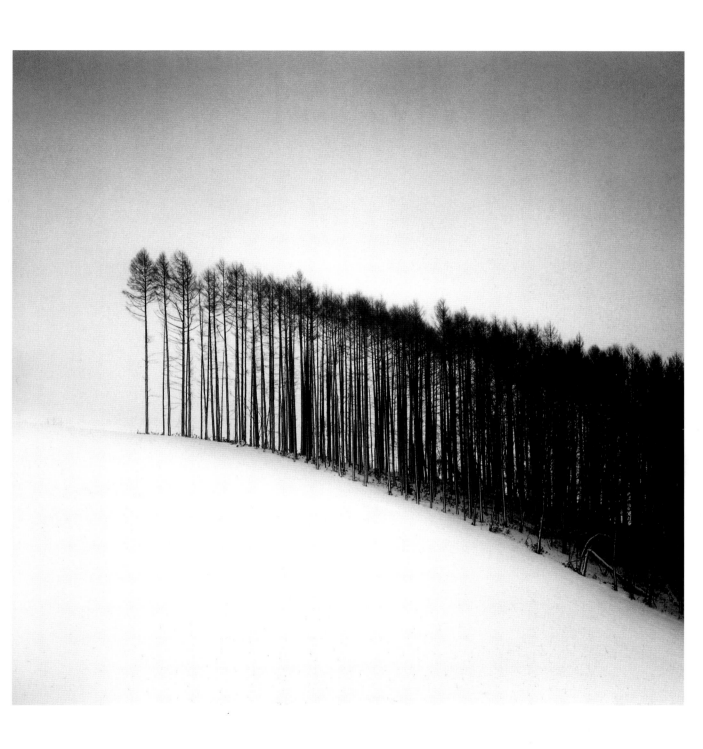

Forest Edge, Hokuto, Hokkaido, Japan, 2004

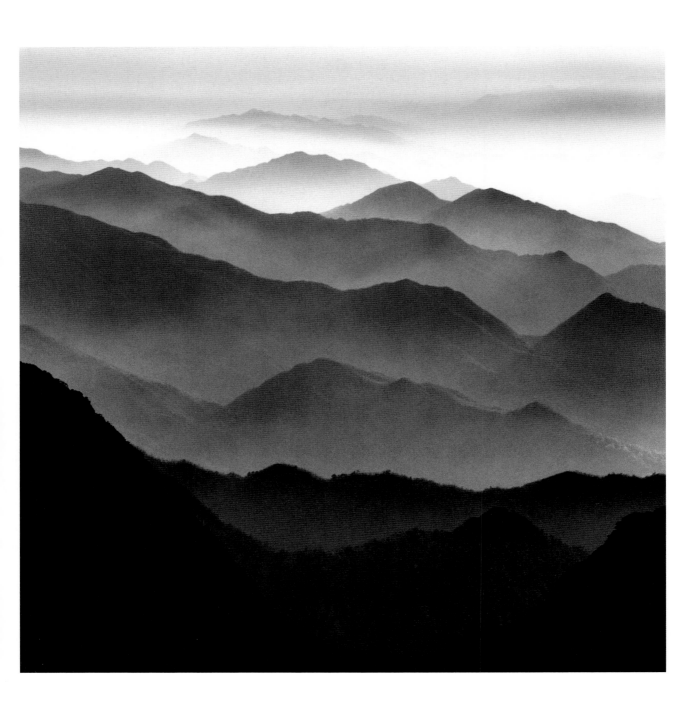

Huangshan Mountains, Study 42, Anhui, China, 2010

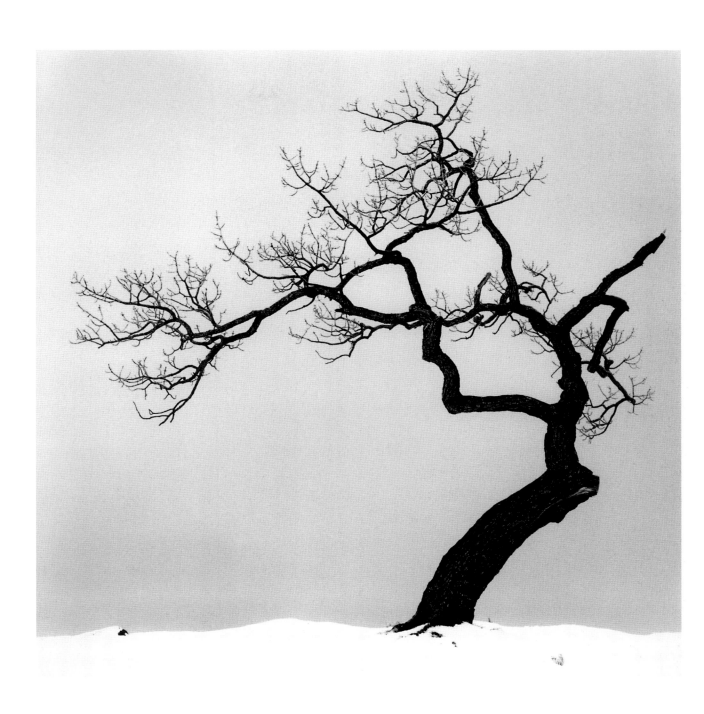

Kussharo Lake Tree, Study 1, Kotan, Hokkaido, Japan, 2002

CINDY SHERMAN

Cindy Sherman portrays herself in her photographs— not as Cindy Sherman, but as her own and only model. The fundamental theme of her images is invariably the question of identity and reality.

CINDY SHERMAN

Cindy Sherman rose to fame with her *Untitled Film Stills*, which she created between 1977 and 1980. It is a series of black-and-white photographs resembling the stills and ad images of film productions. They depict scenes from films that do not exist, but they are created in such a way that viewers have the feeling of having seen a film with just such a scene. As in many of her other series, she plays with clichés and stereotypes, in this case with Hollywood's image of women and with film noir of the 1950s and 1960s. Everything—costumes, lighting, camera settings, poses, and the size of the photos—is reminiscent of the era. And as in all her other series, Sherman does not title the images but merely assigns a number, leaving it to the viewer the possibility of creating associations: "The still must tease with the promise of a story the viewer of it itches to be told." They are not proper narratives but rather scenes, fragments lacking all context—stories without narration or narratives without a story.

In the *History Portraits* (1988–90), Sherman plays with art history and the different forms of depiction and representation in different eras. She gives free rein to her love of dressing up and at the same time comments ironically on idealized images by means of exaggeration. This also applies to many of the other series in which she stages herself in new contexts. In the series *Clowns* (2003–04), she plays with the abstraction of the person who might be hiding behind the mask.

In *Centerfolds* (1981), Sherman subverts expectations triggered by the word that refers to the foldout photos in magazines such as *Playboy*: "In content I wanted a man opening up the magazine suddenly look at it with an expectation of something lascivious and then feel like the violator that they would be." They are voyeuristic pictures in which the woman is viewed in a vulnerable position from above, and for which Sherman received criticism from feminists. And yet, the submissive attitude toward men was certainly not her intention. Even early in her career she bristled at the injustice that works by men commanded much higher prices on the art market than those by women: "On the other hand, maybe that was the reason why I had such a fire under my ass. I wanted to show it to those men." And, in a certain sense, she did: in 2011 her photograph *Untitled #96* from the *Centerfolds* series sold at auction for $3.89 million, making it one of the most expensive photographs of all time.

A central theme runs through all of the photos and series, one which Sherman continually restages in each image: the presentation of women and their role models. This also applies to her later series, including *Society Portraits* (2008), which deals with aging and the surgical options for improving one's appearance. The photographer explained, "It is sad that we are losing role models for aging. . . . Perhaps there should be at least a few women who grow older naturally, without such operations. To serve as role models for younger women."

Untitled #216 (from "History Portraits"),1989

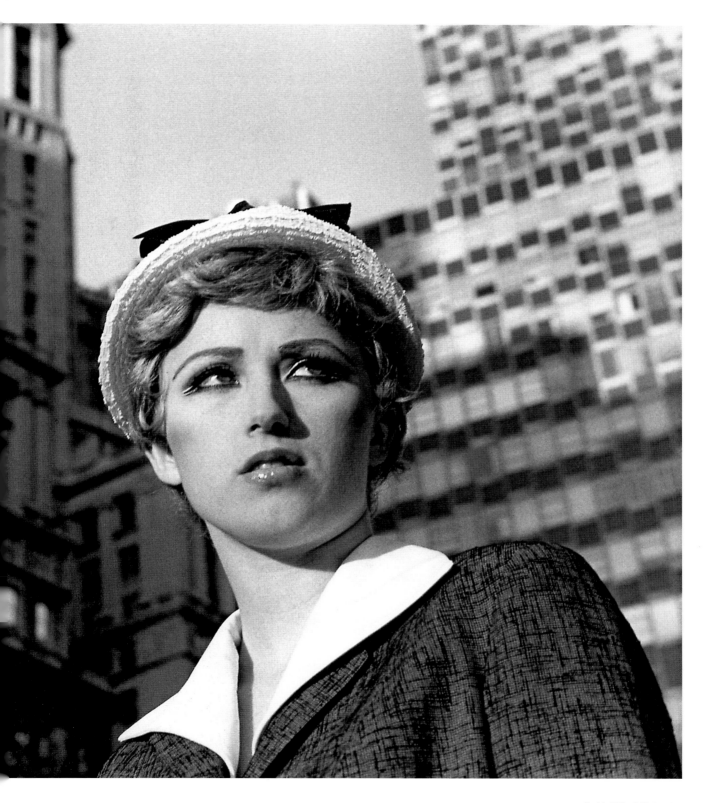

Untitled Film Still #21, 1978

28 THOMAS STRUTH

Thomas Struth's photographs explore complex relationships: the interactions between human activity and the built environment, between parent and child, between past and present, and between artist and viewer. Some of his best-known works capture many of these interactions in a single image.

THOMAS STRUTH

1954 Born in Geldern, Germany

1973–80
 Studied at the Kunstakademie Düsseldorf

1976 First exhibition of his architectural photos

1983 Began making portrait photos

1989 *Museum Photographs* exhibition

1993–96
 Taught at the Staatliche Hochschule für Gestaltung Karlsruhe

1998–2007
 Produced a series of photographs featuring forest scenes

2010 Major retrospective exhibition at the Kunsthaus Zürich

2016 Solo exhibition *Nature & Politics* in Essen, Berlin, and Atlanta

German photographer Thomas Struth has described his work as exploring "different situations in which people find themselves. About streets as public space, where specific and collective attitudes affect us every day. . . . About the contemplation of art as a self-reflection: being confronted with your own imagination. . . . and with the artist's vision of the world at the same time. About people visiting a historic monument as mass tourists and yet as unique persons. About people being both fascinated with and passively exposed to concepts of the future that are difficult but necessary to relate to in an active way." Over time, Struth has developed different photographic methods for capturing these aesthetic and social concerns.

Thomas Struth studied at the Kunstakademie Düsseldorf in the 1970s, during a time of intense creativity in German art. Among his teachers was Gerhard Richter, who used photography as the basis for much of his conceptual art. He also worked with Bernd and Hilla Becher, who developed an "objective" style of photographing historic and industrial architecture, focusing on the buildings' form and structure and their relationship to their environment. Struth's early series of black-and-white images from the late 1970s, which featured unpopulated street scenes in London and New York City, followed the Bechers' style. But the artist would soon begin to explore ways of incorporating human connections in his work. In 1985, he began making portraits of families in different countries. These images were designed as more than simple documentation. They were meant to suggest how individual family members relate to one another and how the family as a whole relates to its particular country's history and culture.

All of Struth's early artistic experiments would lead to his most characteristic works, which he began producing in the late 1980s. They include the *Museum Photographs* series (1989–2007), as well as later photos depicting crowd scenes in cathedrals, city squares, and other public spaces. One such work features a crowd in the Milan Cathedral in 1998. The image combines Struth's ability to depict compelling architectural form, space, and detail with his interest in how humans interact with that space and with one another—interactions that are at once culturally determined yet subtly individualized.

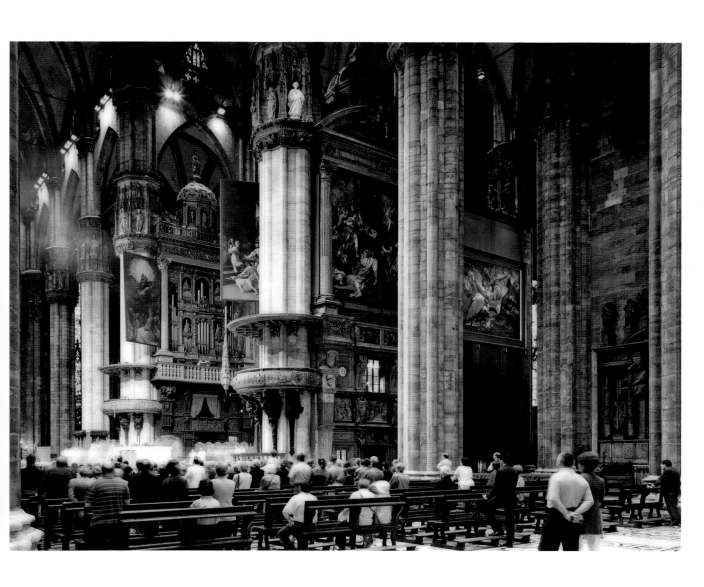

Milan Cathedral, Milan, 1998

ELLEN VON UNWERTH

So often we see those slightly sullen-looking women and ultra-cool men gazing out at us from the pages of fashion magazines, and we ask ourselves whether these people can also feel joy. Not so with the photographs of Ellen von Unwerth. Rarely do we come across such joie de vivre, such joy, as in her images.

ELLEN VON UNWERTH

1954 Born in Frankfurt am Main, Germany

Spent her childhood between orphanages and foster homes

1971 Moved to Munich; worked as a clown's assistant at the Roncalli Circus; discovered as a model

1975 Moved to Paris

1986 Decided to become a photographer

Worked for *Vogue*, *Interview*, *Vanity Fair*, *i-D*, among others

1994 *Snaps*

1998 *Couples; Wicked*

2009 *Fräulein*

2012 *The Story of Olga*

Lives and works in Paris and New York

www.ellenvonunwerth.com
www.instagram.com/ellenvonunwerth

For ten years Ellen von Unwerth was herself a fashion model, so she knows how it feels. And she knows that most photographers have a very explicit idea of how a model should move, or not move at all. But she always wanted more movement, to "play around" in front of the lens, something most photographers wouldn't allow. So she began taking photos herself, with the help of her then boyfriend, himself a photographer. Von Unwerth reached a turning point in 1986, when pictures of local children she had taken while on a modeling job in Kenya were published in *Jill* magazine, convincing her of the new direction she was to take. For one of her first major assignments, in 1989, Von Unwerth chose a young German model that reminded her of Brigitte Bardot: Claudia Schiffer. The resulting series of photos launched the meteoric rise of them both.

At the time, fashion photography was dominated by elaborate productions in which models were presented less like vivacious young women than groomed-to-perfection "goddesses" in a materialistic, unattainable, and translucent parallel universe full of static figures, impassive faces, and frozen gestures. Ellen von Unwerth went in the exact opposite direction; now a photographer, she had the opportunity to make a radical break from this stiltedness, and she did: "I just like people with personality, and who have fun in front of my camera!" In 1991, she won first prize at the International Festival of Fashion Photography, and in 1998 *American Photo* named her one of the most important people in photography. She developed her own dynamic, joyful, and positively erotic style that caused a sensation. With a reportage-like spontaneity, she staged vignettes in which, like a director, she arranged her protagonists in the scene. By her own admission, her work's eroticism creates more problems for male viewers than female ones: "I consider myself a feminist; I was always a strong woman, always standing up for women's rights. I like women who look like they have their life under control. But people do overdo it and become so serious, it doesn't mean you can't still have fun." And it is the fun that, putting aside the beauty, is one of the principal facets of Von Unwerth's photography: "I like the life. I like to capture life, not just the dresses they are wearing." So it almost goes without saying that among the photographers who have influenced her the most, alongside the name of Helmut Newton (1920–2004) we should find that of Jacques-Henri Lartigue (1894–1986), likewise renowned for images simply teeming with the joys of life.

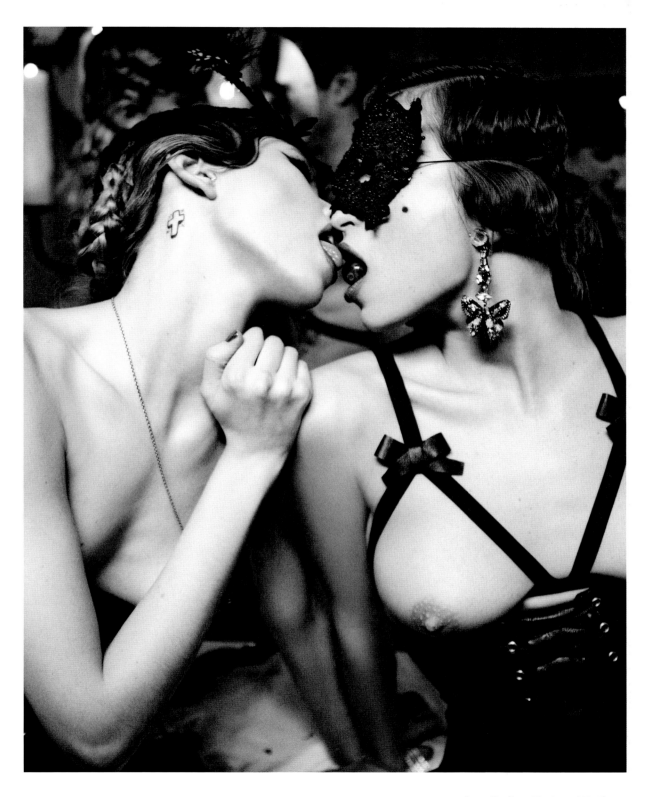

Cherry Kiss (from "The Story of Olga"), 2011

EDWARD BURTYNSKY

> "I would describe my photography as a quiet lament over the loss of the natural world." So observed the Canadian photographer and artist Edward Burtynsky, whose large-format images reveal how we as humans are treating the planet Earth, and how we are altering it.

EDWARD BURTYNSKY

1955 Born in St. Catharines, Ontario, Canada

1982 BA in Photography, Ryerson University, Toronto

1985 Founded Toronto Image Works (photo and new media business)

1988 *Breaking Ground*

1994 *Quarries* (book)

2005 *China* (book)

2006 *Manufactured Landscapes*, documentary directed by Jennifer Baichwal

2006 Nominated Officer of the Order of Canada

2007–13
 Receives various honorary degrees in jurisprudence and the fine arts

2013 *Watermark*, documentary directed by Jennifer Baichwal

www.edwardburtynsky.com

"When I started this work, thirty years ago, you heard murmurings [about] environmental degradation. But that murmur has become a shout today." Edward Burtynsky depicts humanity's destruction of the environment in a highly personal, intensive fashion. In his early images, this destruction, albeit rather obvious, is often only visible at second glance. Only when we as viewers become conscious of what he is actually showing us do we understand the image and are shocked by it. For example, a landscape with a bright orange river running through it both fascinates and disturbs—and we ultimately learn that the color of the river is the result of nickel contamination. Burtynsky calls his pictures "Manufactured Landscapes," and hits the nail on the head: giant mines, immense highway junctions, or old car tires stacked up by the thousands form, as it were, new landscapes within our world. In order to transmit the tremendous urgency, from the start the photographer used 4×5 cameras, which offered the possibility of making very large prints. Through his photography Burtynsky shows an eerily beautiful side the world and grants us, as he says, a "second glimpse of what we call progress." In *Oil* (2009), he illustrates the importance of oil and the danger it holds for our world, its extraction and use, and the impact this has on nature and ultimately on humanity.

Burtynsky is not simply a documentary photographer; he considers himself first and foremost an artist whose work draws attention to environmental issues: "As an artist I am constantly inventing new ways to tell that same story." In his most recent project, *Water*, he investigates the significance of our most important resource, water, and how we treat it. To do so he overcomes gravity, so to speak, and raises his—typically elevated—perspective up into the air. Exceedingly high towers, drones, helicopters, and the use of digital cameras that he can operate remotely from the ground give him an extreme perspective that result in quite a different kind of image, and in new, sometimes alarming—but no less artistic—insights. Viewed from high above, landscapes that have been shaped or even disfigured by man and industry might resemble in their composition a canvas by Mark Rothko, or accumulations of scrap metal might recall the Abstract Expressionism of Jackson Pollock. Beyond aesthetics, however, Burtynsky's images offer a window onto an abyss of alteration and destruction that sends a shiver down the viewer's spine. Which is good, because Burtynsky wants to shake people up with his work, creating awareness and encouraging a more sustainable course of action.

And Burtynsky continues to keep up on technological advances, which he invariably incorporates into his photography work. In 2014, he founded a 3D printing technology company that for him represents the logical next step in the development from analog to digital to, now, three-dimensional images—a kind of Photography 3.0.

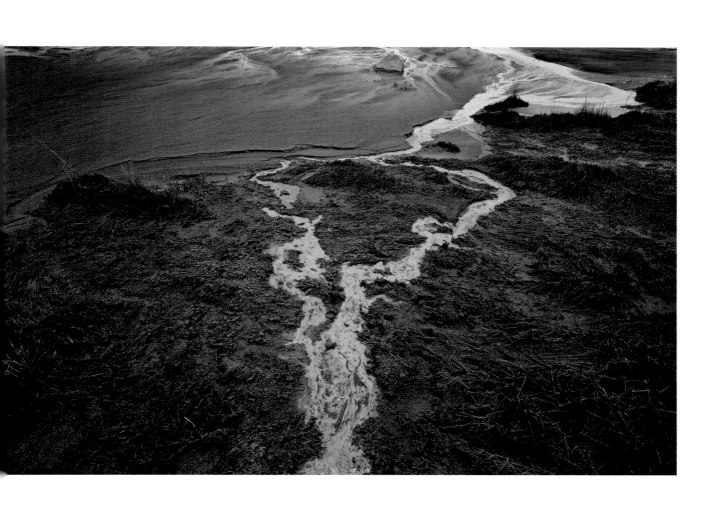

Nickel Tailings #31, Sudbury, Ontario, 1996

31

ANTON CORBIJN

"My work is not quite perfect. Perhaps it still contains something of life. Because perfection often prevents the work from breathing." The vitality in Anton Corbijn's photographs is less a result of his continued preference for analog over digital and more with his approach to the craft.

ANTON CORBIJN

www.antoncorbijn.com

The "portrait photographer who also photographs rock musicians"—as Anton Corbijn described himself—still prefers to take his photos with an analog Hasselblad. Though for such a seasoned professional the risk of not getting what he is looking for is minimal, this uncertainty contributes to the attractiveness of keeping to this method of working. And unlike many of his colleagues, Corbijn uses as few technical aids as possible: "I believe that photography is a very simple affair. I meet people—and the camera is only something like a recording machine. My work has nothing to do with the circus that other people create, although of course that can also result in an excellent photo."

It was a love of music that drove Corbijn to initially begin taking photographs; it was a way of getting as close as possible to the musicians. And he has succeeded better than anyone else. Since the late 1970s Anton Corbijn is to the international stage, what David Bailey had been to England throughout the 1960s and 1970s. He has portrayed and often enjoyed long-lasting friendships with, among others, U2, Depeche Mode, David Bowie, Miles Davis, the Rolling Stones, Herbert Grönemeyer, Captain Beefheart, even the popular German bandleader James "Hansi" Last. Corbijn is often responsible for creating, in his own unique way, a new image for his subject. Depeche Mode, for example, sought in Corbijn's earnest and distinguished style a way to distance themselves from the image that had followed them from their beginnings as a "normal" pop band. The same goes for his collaboration with U2. And it worked.

But you'd be mistaken if you're under the impression that musicians are his only subjects; since the late 1980s Corbijn's photographed many artists from a range of disciplines, in particular directors, actors, and painters. Such as Robert De Niro, Lucian Freud, Peter Doig, Martin Scorsese, and Jeff Koons as well as the likes of Nelson Mandela and Kate Moss.

In addition to the practice of always shooting hand-held, also indispensable to Corbijn's aesthetic is the specific look of his prints from very early on. Initially printing just contrasty black and white, in the 1990s he started using a lithographic developer in combination with a Japanese paper creating "lith prints." This method imparts a greater contrast and lend the photographs a more painterly feel. For his fake paparazzi series *33 Still Lives* from the late 1990s, he used Polapan film printed on color paper to achieve a uniform grainy, bluish effect.

In his portraits he is looking for the inner beauty and struggle of those he has before his lens—and it would appear he finds it. Keith Richards has observed, "All great photographers have a third eye. Anton has three third eyes." And Corbijn himself said, "As an artist, you say something about yourself in your work. That is what distinguishes your own work from that of others." In his case, it is perhaps a certain sobriety that he inherited from his Protestant upbringing.

Alongside photography, Corbijn has directed a number of successful and pioneering music videos, has designed record covers as well as concert stage sets, and is now a respected film director. In 2007 he directed *Control*, a film about Ian Curtis, the singer of Joy Division, one of the bands that had originally attracted him to London. As a director Corbijn has worked with acting greats such as George Clooney and Philip Seymour Hoffman, and in 2010 he also created the world's *Smallest Shortest Film* for the Dutch postal service. It lasts just over a second, and its thirty frames were released on a postage stamp.

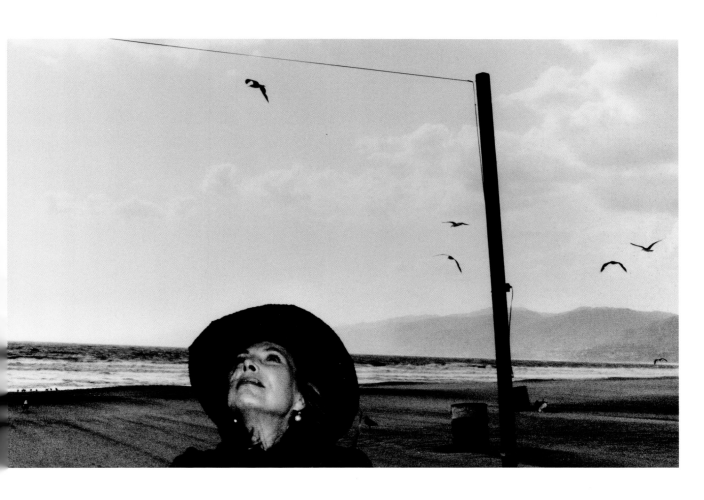

Joni Mitchell, Santa Monica, 1999

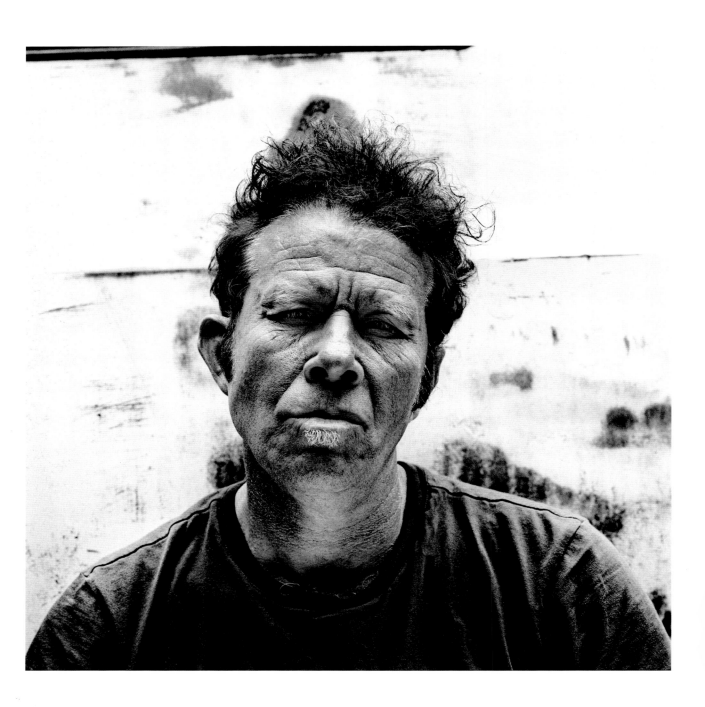

Tom Waits, Petaluma, 2004

Gerhard Richter, Cologne, 2010

32

ANDREAS GURSKY

In the late 1980s, Andreas Gursky, together with Thomas Ruff and other members of the Becher School as well as Jeff Wall, were among the first photographers to make "museum-size" prints. They caused quite a sensation, and in the process earned for photography a new prominence and a rightful place in the art world.

ANDREAS GURSKY

1955 Born in Leipzig, Germany
Both his father and grandfather were photographers

From 1977
Studied photography at the Folkwangschule, Essen

1981–87
Transferred to the Kunstakademie Düsseldorf; studied under Bernd and Hilla Becher; formed part of the Düsseldorf School along with Axel Hütte, Thomas Struth, and others

2001 Exhibition at the Museum of Modern Art, New York

2008 Received the Goslarer Kaiserring

2010 Professor at the Kunstakademie Düsseldorf

Early in his career, Andreas Gursky took photographs with analog, large-format cameras. Later, with the arrival of digital technology, he freed himself from "simple reproduction" and created his own realities in his images. As in painting, the actual photographic work is no longer limited by the location it was taken but rather can be composed of various individual photos. Gursky even compares the two: "I would say that with today's digital possibilities there is now no difference between photography and painting." Gursky's images are not created, like most photographs, in a single moment, but rather they are developed piece by piece from various shots that he then assembles on the computer to create a whole. His images are a combination of detailed and remote views: "My images are always composed from two positions. Viewed from extremely close up, they are legible down to the smallest detail. From a distance, they turn into mega-signs." Because of this ambiguity of proximity and distance, the works ideally need to be on a "museum scale." Each subject becomes a mass representation: an asparagus field in Beelitz extends to the horizon; a basket weaving workshop becomes a massive operation; a Formula 1 racetrack in Bahrain is transformed into a seemingly endless desert graphic; and the three-story Westfalenhalle in Dortmund is "sampled" to create an eighteen-story techno temple during the Mayday festival. Gursky's images play with the aura of authenticity traditionally ascribed to photography, in which what you see in the photo is actually what was in front of the camera. For his pictures, the following rule applies: "Any claims on the truth in [my] pictures are only to be answered in the sense that a particular event did in fact happen and did take place in the here and now." But even this certainty crumbles in his more recent works.

Gursky condenses time, combining multiple photographs of an event taken over a determined period. There is no longer that "decisive moment" of exposure that had for so long influenced photography, but many moments that, combined into one image, form a new artistic moment. Everything that is in the photograph really did happen in front of the lens, but in different contexts and at different times. "I never claim that the picture is a reproduction of reality. . . . There is always a mixture of invention and reality." His images are temporally compressed and and also often, as it were, spatially stretched. They function somewhat like memories of a place or a situation that is altered in spirit but with a real point of reference. They are the artistic realization of a real situation, or, as Gursky himself says, "The picture is not, strictly speaking, true, but it is truthful."

And it is not only the dimensions of Gursky's images that are fit for a museum, but also the prices. In 2011, *Rhein II* (1999), at $4.3 million, was the world's most expensive photograph, a title his work has previously held: in 2007, his *99 Cent II Diptychon* (2001) sold at auction for $3.3 million; and in 2006, his *99 Cent* (1999) sold for $2.2 million. Ironically, the latter two works depict a discount store where, as the title suggests, no article costs more than ninety-nine cents.

Mayday V, 2006

Rhein II, 1999

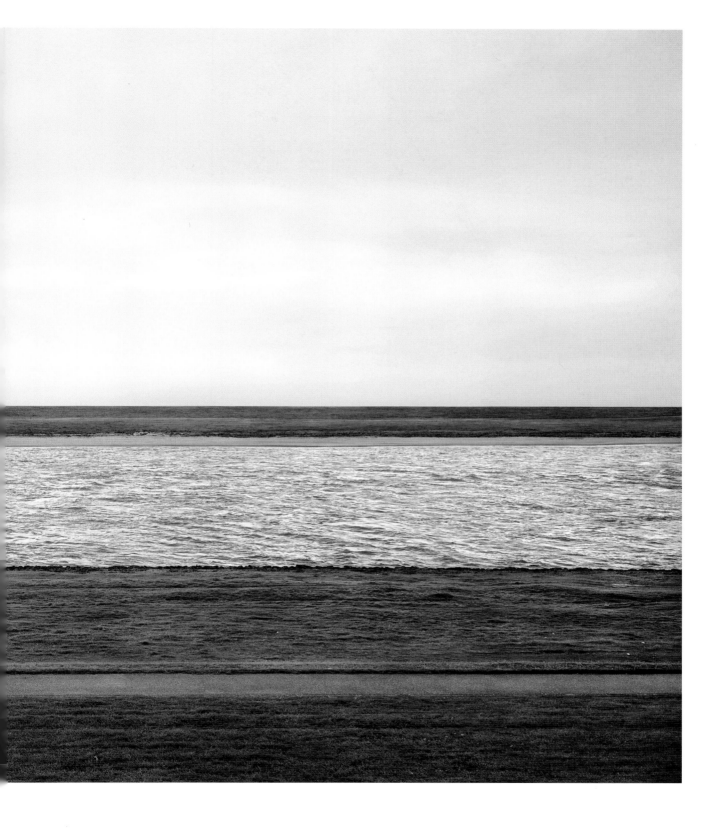

33

PAUL GRAHAM

PAUL GRAHAM

www.paulgrahamarchive.com
www.carliergebauer.com

Paul Graham's early works date from the 1980s, a time when photojournalism was still heavily influenced by Henri Cartier-Bresson's black-and-white images of the "decisive moment," and color was still regarded as kitsch and trite. In England, Margaret Thatcher was in power and radically altering the state. The Iron Lady's policies resulted in the crowded unemployment and welfare offices whose dreariness Paul Graham documented in his series *Beyond Caring* (1986). Taken from the perspective of someone who himself relied on these services, Graham photographed the people as he waited his turn. Undramatic yet incisive. The fact that he photographed the work in color earned him a fair bit of criticism: color was too cheerful, too positive, simply too frivolous for such a controversial subject. For Graham, as well as for Martin Parr and other photographers of Britain's so-called New Colour Documentary, however, color expanded documentary photography's possibilities by introducing new formal and symbolic elements.

Graham does not photograph the exceptional but rather the obvious. In his book on the conflict in Northern Ireland, *Troubled Land* (1987), it feels at first glance as if one is looking at a collection of peaceful landscapes. But only at first, because we then notice references to the smoldering conflict in small details: a Union Jack in a tree, a soldier running on a roundabout, or colorfully painted curbs that mark the boundaries between confessions. As in many of his works, Graham's view of the seemingly incidental teaches us to look more carefully, and that life is generally not composed of spectacular and photogenic moments.

His American works—*American Night*, *A Shimmer of Possibility*, *The Present*—deal with both seeing and taking pictures. Some of his series are the photographic realization of how we look at the world. We see something, are distracted, briefly look elsewhere, notice a small detail, and then look back at whatever first caught our attention. Our gaze is constantly on the move, focusing one moment on one thing and the next moment on another. Graham focuses his gaze on the completely normal everyday moments that make up real life, because life is composed for the most part not of decisive moments but the moments in between. "Far too many photographers think that if they take a picture of something interesting, they will automatically have an interesting photograph. But it doesn't work like that."

His photos are particularly effective in the context of his books. He has virtually without peer when it comes to innovative and associative image sequencing. For example, over the length of the *End of Age* (1999), the orientation of the portraits of the young club-goers rotates 360 degrees, an effect subtly "foisted" on the viewer. In 2011, Paris Photo selected Graham's *A Shimmer of Possibility* as the best photo book of the previous fifteen years.

With his photography, Graham has long since left behind the classic documentary form. Photos "about" something are dispensed with in favor of small observations, visual poems that transform documentation into art.

Rockefeller Center, 23rd April 2010, 1.50.50 pm, 2010

34 THOMAS RUFF

While the work of German photographer Thomas Ruff may appear realistic, his portraits play with notions of reality and image. These passport-like photos draw viewers away from individual personalities and toward other elements—texture, color, composition—that make up a work of art.

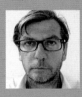

THOMAS RUFF

1958 Born in Zell am Harmersbach, Germany

1977–85 Studied photography at the Kunstakademie Düsseldorf

1981–85 Produced his first group of passport-like portrait photographs

1987–91 Produced his architectural *Häuser* series

1997 Began creating a series of digitally produced, poster-like photographic works called *Plakat*

2006 Infinity Award: Art, International Center of Photography

"My images are not images of reality but show a kind of second reality, the image of the image."

Thomas Ruff was born in a small town in Germany's Black Forest in 1958. Like many aspiring photographers in his country, he enrolled at the Kunstakademie Düsseldorf in the 1970s to study with Bernd and Hilla Becher. This husband-and-wife team became famous for their photographs of local architecture—including grain elevators and water towers—that presented the buildings in direct, portrait-like images that focused on the building's form. This strict compositional technique would inspire the work of many famous students, including Candida Höfer, Andreas Gursky, and Thomas Struth.

By 1981, Ruff had begun to focus on the human portrait as a means of exploring the formal qualities of the image. He would shoot his sitters either head-on or in profile, against plain or white backgrounds, and he would have them adopt an expressionless countenance. The results were pictures that resembled anonymous passport photos, images that stripped the sitters of any unique personality. Ruff would then print the photographs in a large format, as in the 1989 example shown here. The large scale of the portrait, and its lack of individual human character, makes a viewer's eye focus on the details and overall structure of the composition itself. In this example, the symmetry of the image and its contrasts of texture (the soft red folds of the shirt against the stubbly skin) are emphasized. Ruff's work also questions the notion of portrait photography as expressing an individual's true "reality." Some critics have compared his work to the photorealist portraits of Chuck Close, which also use monumental size and expressionless faces to highlight compositional details.

Beginning in the late 1980s, Ruff would move away from portrait motifs. His series of photographs from 1995 capture the streets of Düsseldorf at night in a hazy mist. These images seem to resemble the nocturnal TV videos of modern war, where the destructive force of an air raid is obscured by the opaque sky and soft city lights. These images "document" war in ways that offer little insight into its harsh realities. More recently, Ruff has been experimenting with alternative photographic techniques. His "photograms" from the 2010s display abstract compositions, which were developed by manipulating photographic paper and then exposing it to light. Such works further reveal Ruff's lifelong interest in the photograph as image rather than as a means of describing real life.

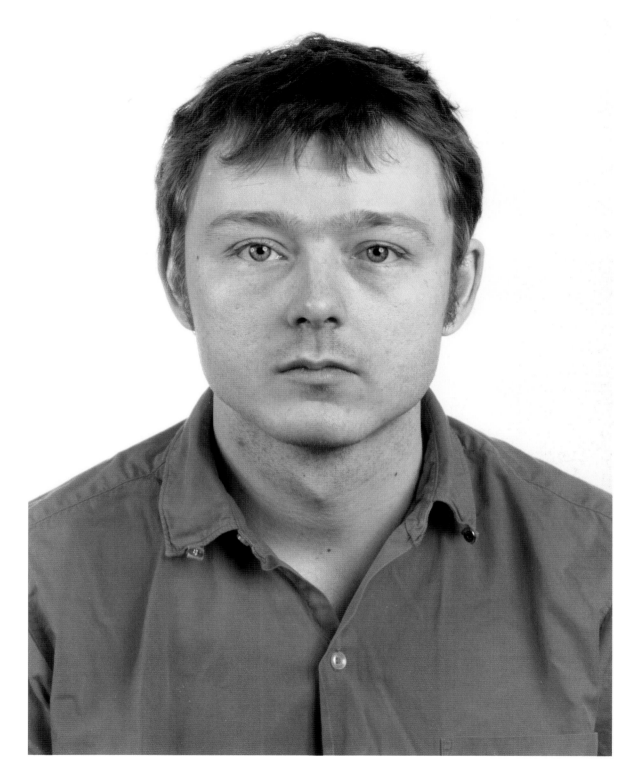

Portrait 1989 (F.Terhardt), 1989

35

RINEKE DIJKSTRA

Young people on the
beach, alone, wearing
only swimsuits or bikinis,
look earnestly into the
camera. Postures still
uncertain, and a gaze
that hovers between
past and future, between
childhood and adulthood.

In the 1990s, the Dutch photographer Rineke Dijkstra earned renown for her photographs of pubescent youths standing hesitantly and timidly before the camera, directly meeting the viewer's gaze. Dijkstra shot this series of photographs between 1992 and 1996 in the United States, Poland, Ukraine, Belgium, and England. Taking a classic approach to portraiture, she concentrates solely on the person, without attributes or an explanatory background. And this approach results in sober, spectacularly nonchalant images. The simple technique is always the same: shot frontally with a 4×5 camera and a fill flash; the photographer gives few direc- tions and gives her subjects time in front of the camera to relax and find their own posture. She explains, "All these poses look so unfinished, like sketches, similar to the moment of transition when one passes from childhood to adulthood. I think it is very important for me to capture this moment." The concept of transition is an important theme that runs throughout her work, along with the question of what remains of a person when the normal masks and mechanisms we use to protect ourselves fall away. With the young, this protective shell, which often later hardens into a suit of armor, is not as pronounced. As adult viewers, we remember with relief having for the most part left behind this complicated phase of life, plagued with insecurities, and we can simply empathize with the young people before us.

Dijkstra's photographs are reminiscent in their technical perfection and simplicity of the work *People of the 20th Century* by August Sander (1876–1964), and in their conceptual ap- proach of the Becher School, albeit without the intellectual superstructure.

In practically all of the series in her photographic work, such as the beach portraits or her park images, Dijkstra focuses on the intensity and poignancy of a moment. But she is also interested in capturing the moment after an exhausting or life-threatening action, where a wide range of complex, almost contradictory emotions like exhaustion, pride, joy, and fear are vis- ible in one person. Her photographs capture, for example, young Israeli soldiers after their first shooting exercise, or bullfighters who have little of the proud *torero*, but who, splattered with blood and with their clothing torn, look exhaustedly into the camera. Or mothers who have just given birth and, hovering between exhaustion, joy, and protectiveness, stand with their child in their arms in front of a bare wall. It takes a certain courage to take on this kind of portrait pho- tography, and to be confronted with the results.

Time and again the question that pervades Dijkstra's work arises: What remains when we are thrown back on our own resources, when nothing more stands between ourselves and oth- ers? It is the question of identity that Dijkstra plainly and poignantly poses with her portraits.

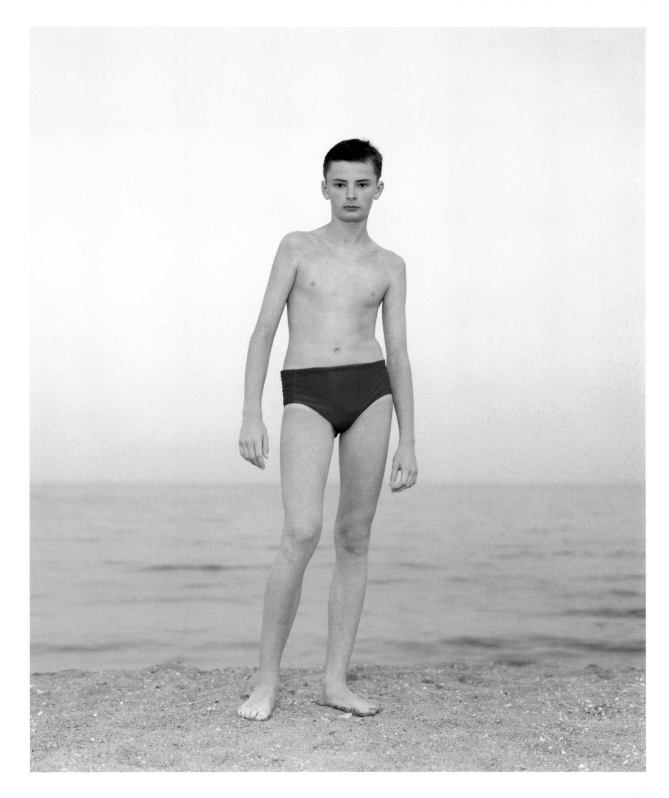

Odessa, Ukraine, August 4, 1993

36

ANTOINE D'AGATA

ANTOINE D'AGATA

Antoine d'Agata is indeed very close to the people and situations that he captures and communicates with his camera. He tells the stories of people with whom he spends hours, nights, days, months, with whom he takes drugs and has sex. Disturbingly nebulous and blurry images of decimated bodies that are the product of long exposures is the hallmark of d'Agata's work. The bodies are reminiscent of the canvases of English painter Francis Bacon and the photography of Nan Goldin, one of d'Agata's inspirations whose own work seems almost demure in comparison.

D'Agata steps out from behind the camera to get even closer to his subjects, and to himself form part of his visual world, using a tripod, self-timers, or having someone else release the shutter. In order to reach the intensity that he does, d'Agata spares himself and the observer nothing. His obsessive images from the murky demimonde and bordellos of the world are gripping, brutal, frightening, and at times difficult to endure. He draws no line between the personal and the professional, and one gets the sense that he truly does photograph everything he experiences, come what may. It is seldom beautiful, but beauty is not a category about which the photographer obsesses. They are the photos of a driven man, an addict, who reaches for his camera at times when others would have long put it away. And d'Agata will often do whatever it takes to immerse himself deeper into a given situation: "I've used every possible method I've been able to come up with to give up control. I'll use whatever I can put my hand on—alcohol, drugs, rage, sex, or fear—to push my own limits and make sure the final image is not an illustration or a statement."

The camera was also a sort of lifeline for d'Agata, to ensure that he would stay afloat in the world he in which he lived for many years. He has succeeded in developing entirely new expressive possibilities for photography that have astonished, touched, and won over both amateurs and professionals. Antoine d'Agata seems to have an insatiable need to communicate, through both images and words; it is a need that borders on compulsion, to show—almost to scream about—everything that moves and drives him, as if it would otherwise tear him to pieces. A viewer of his work might wonder what is d'Agata's intention with his images. Are they an indictment of the world and its pervasive industries of drugs and sex and the victims they create? Or are they an expression of how he deals with his own obsessions and demons and thus some sort of artistic self-therapy? Whatever the answer, d'Agata's photographs reveal an unfamiliar, sinister world that disturbs, distresses, and shocks, which is probably why they take the form that they do, and from which we gather that the world is not as it is but rather as we are.

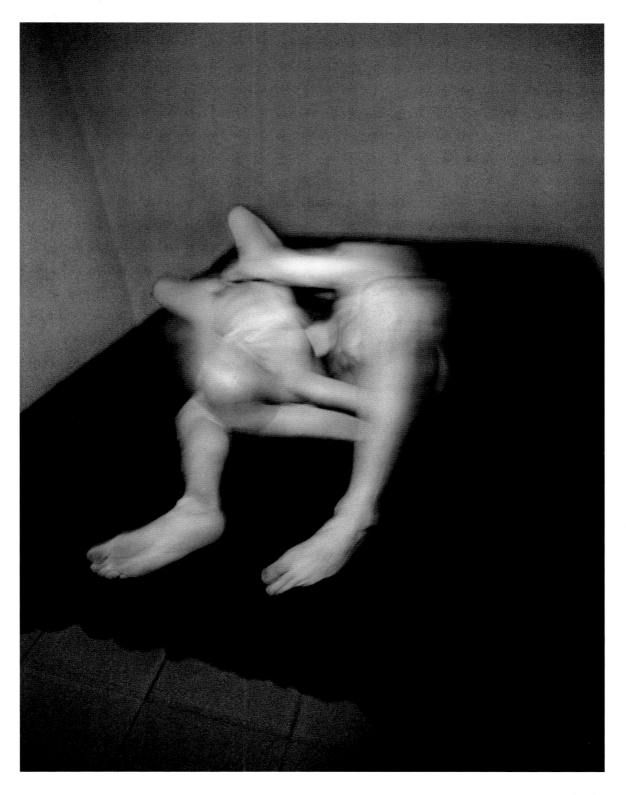

Phnom Penh, Cambodia, 2008

37

DAYANITA SINGH

There are few Indian photographers known in Europe and the United States, perhaps Raghu Rai and Raghubir Singh; women photographers from India, even less. Along with Sooni Taraporevala, who also co-wrote the screenplay for *Salaam Bombay!*, it is Dayanita Singh who has made a name for herself on the international stage.

DAYANITA SINGH

1961 Born in New Delhi, India

1980–86
Studied visual communication at National Institute of Design, Ahmedabad

1986–88
Studied documentary photography and photojournalism under Mary Ellen Mark at the International Center of Photography

1986 *Zakir Hussain*
Worked as a photojournalist

2001 *Myself Mona Ahmed*

2007 *Go Away Closer*

2010 *Dream Villa*

2014 *Museum of Chance*; Chevalier de l'Ordre des Arts et des Lettres

www.dayanitasingh.com

Because so few women photographers from India are known, Dayanita Singh has been put in the spotlight and feels that she is often pigeonholed as an Indian photographer: "Please look at my work and don't worry about whether I am Indian or Pakistani or Swiss or whatever. Why is my nationality so important?" She has every right to ask this question, particularly if one considers that at the 2013 Venice Biennale she formed part of the German contribution to the French Pavilion, exhibiting her work alongside that of Chinese artist Ai Weiwei, German Romuald Karmakar, and South African Santu Mofokeng. An event more international in character is hard to imagine.

Nevertheless, Indian themes naturally play an important role in Singh's work. She has realized portraits and reportages about the Indian middle and upper classes, documented the city of Goa, and with her 2001 book *Myself Mona Ahmed* she created a "visual novel" over a period of thirteen years about a eunuch, a *hijra*, who was rejected by his family and now lives, after various twists and turns of fate, in a cemetery in Delhi. "It is the ultimate story of loss," says the photographer, who has maintained a very close friendship with Mona over the years. For her book *File Room* (2013), Singh photographed archives in India overflowing with old paper files that in the digital age look like a chaotic anachronism. In these files you can find documents on everything, from births to marriages, from children to taxes, and even deaths. They are archives about life, about its secrets and dramas. And yet it was the appearance of the archives, the setting, more than the contents that stirred Singh's imagination—perhaps because she herself has a vast archive of works on which she can draw.

After the publication of her first book, her publisher at the time, Walter Keller, advised her to concentrate on taking pictures, on recording everything she fancied, and to leave the matter of exhibitions and books for later. So that is what she did: "I could spend the rest of my life filling these books without taking another picture." And this eventually led her to bookmaking. Because the book is her preferred form, one is ideally not supposed to see Dayanita Singh's photographs in isolation. Which is a pity, for the individual images radiate a great empathy for people and things; and they are also quite simply beautiful, shot primarily in black and white and in medium format. For Singh, however, the power of photography does not lie in the single frame but in the ideal sequence, and for that the book is the most suitable form of presentation. Consequently, she no longer describes herself as just a photographer: "Bookmaking is not a preference; bookmaking is my work. I am a bookmaker. That is my form."

For her work with books, Dayanita Singh has found the ideal partner in the publisher and printer Gerhard Steidl: "Gerhard Steidl is the most important man in my life. And going to Göttingen is the Mecca for me." She has said, "If you ask me where my real home is, I would say: Düstere Strasse in Göttingen. That is the headquarters of Steidl, the publisher of my books."

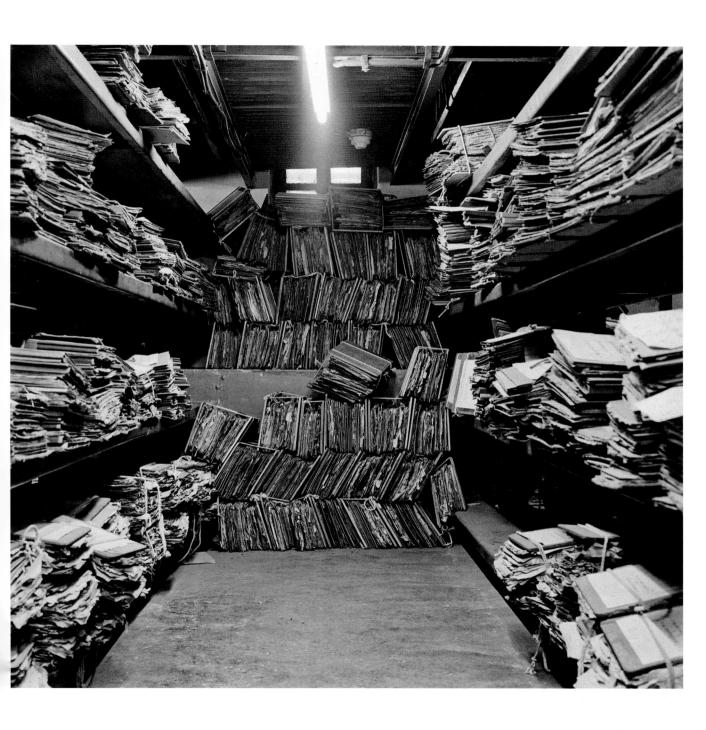

From "File Room," 2013

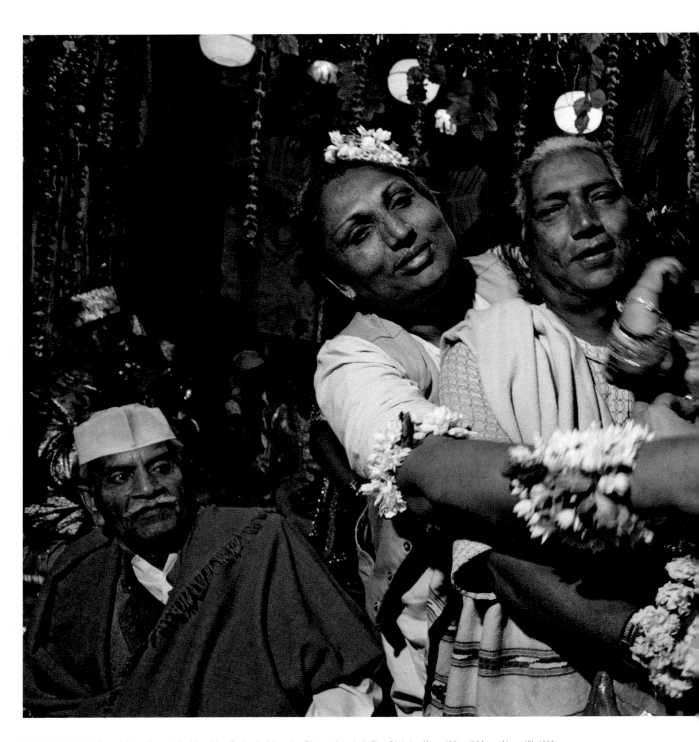

On His Arrival Each Eunuch Was Greeted by Me with a Garland of Jasmine Flower. Ayesha's First Birthday (from "Myself Mona Ahmed"), 1990

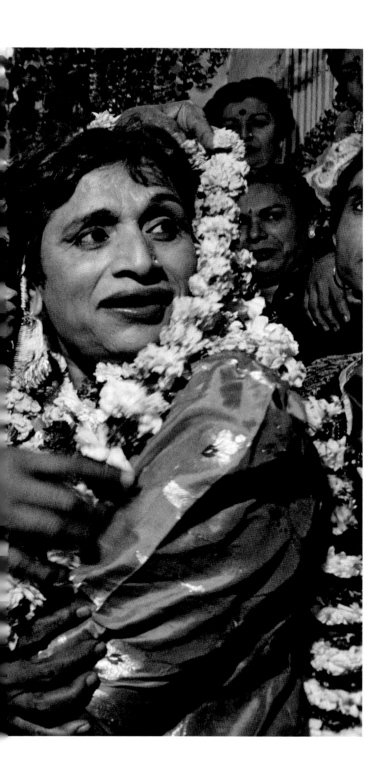

38

GREGORY CREWDSON

GREGORY CREWDSON

1962 Born in Brooklyn, New York, USA

1985 BA in Photography, SUNY Purchase, New York

1988 MFA, Yale University School of Art, New Haven

1995 *Hover*

2002 *Twilight: Photographs by Gregory Crewdson*

2007 *Fireflies*

2009 German Photo Book Prize for *Beneath the Roses: Werke 2003–2007*

Since 2011 Professor at Yale University School of Art

2012 *Gregory Crewdson: Brief Encounters*, directed by Ben Shapiro

www.gagosian.com

Whether Gregory Crewdson has found meaning in the world is not ours to say. And even the question of what his photographs really mean is to some extent nonsensical, because in them he tells stories, whole dramas, of which we know neither the beginning nor end. As viewers we receive his complex images and are forced to figure them out for ourselves. In spite of their elaborate and detailed design, the author/director of these photographic productions provides us with no answers.

We see a motel room from outside; through the window is a white woman with a black baby sleeping; outside, snow is on the ground; the room key is in the open door. A taxi is stopped in the middle of a suburban street at night; a woman stands barefoot on the road; to the right a canopy swing sits on the brightly lit porch of a house. A living room is flooded, but not to the point where the furniture is floating; on her back floats a woman, who has neatly placed her slippers on the stairs. In a parking lot in front of Harry's Supermarket—it is early evening and there only a few cars—a woman is loading her station wagon; a child is already sitting in the car, waiting for them to pull away . . . In his photographs, Crewdson stages American suburban idylls so real in their attention to detail that the overall effect is surreal or uncanny. The images represent moments shortly before or after an event about which we know nothing and for which the photos provide few clues. Influenced by his father's profession as a psychoanalyst, the impression this left can be felt in Crewdson's images. The photographer depicts people, typically alone, in a moment of reflection, in a kind of interior monologue. They are intimate moments related from a certain distance. Something always remains unexplained, because, as Crewdson observed, "We all hide within ourselves a world of secrets."

It is no secret that Crewdson puts an immense amount of work into his images. He is influenced by cinema, particularly by David Lynch, Orson Welles, and Steven Spielberg. Like a major motion picture, his photo projects require location managers, designers, lighting technicians, and directors of photography. According to Crewdson, he produces "single-frame movies" in which the photographer takes on the role of a director, ensuring that his ideas are accurately implemented. Meticulous lighting direction plays an important part, because for Crewdson light is the most important factor in the picture: "The light tells the story." It illuminates the psychological state of the characters, the emotional aspects of the story; the viewer is more or less subtly guided through the intricacies of the images by the lighting direction.

Like Joel Sternfeld and Alec Soth, Crewdson is engaging with small-town suburban America, but he does so, in contrast to the others, through fiction and staged imagery that bears more relation to the work of Jeff Wall. A central theme of Crewdson's photography is the loneliness of people, the relationship between proximity and distance, the space between "anywhere and nowhere": "That tension between detachment and intimacy is really the looming sensibility of the work."

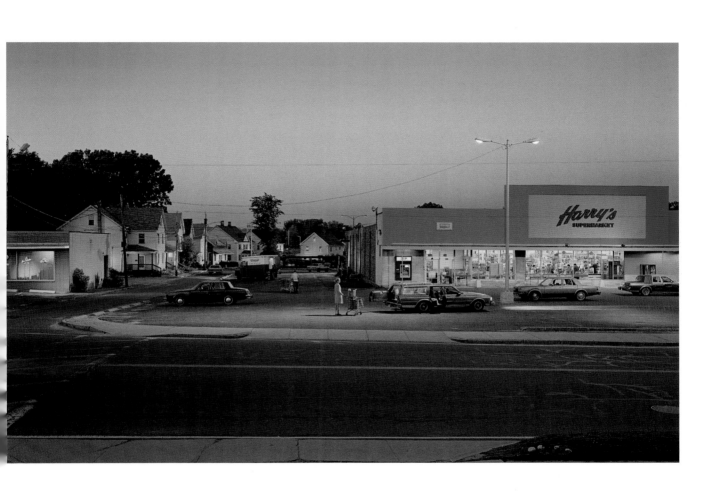

Untitled, 2003–2005

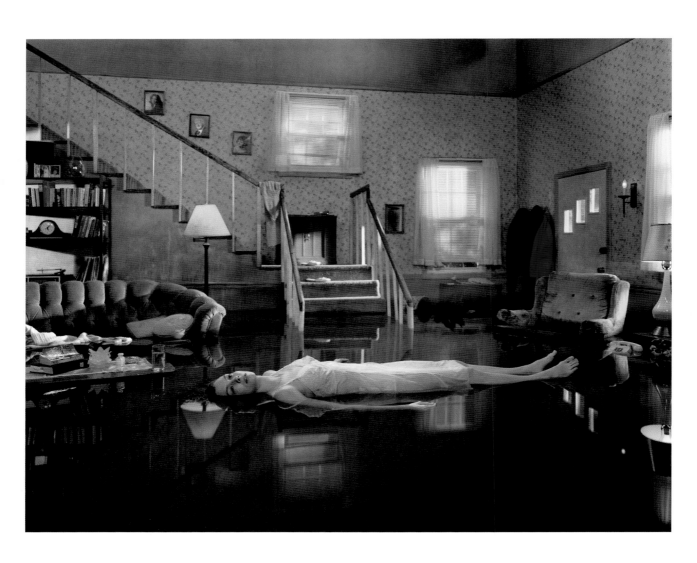

Untitled, 1998–2002

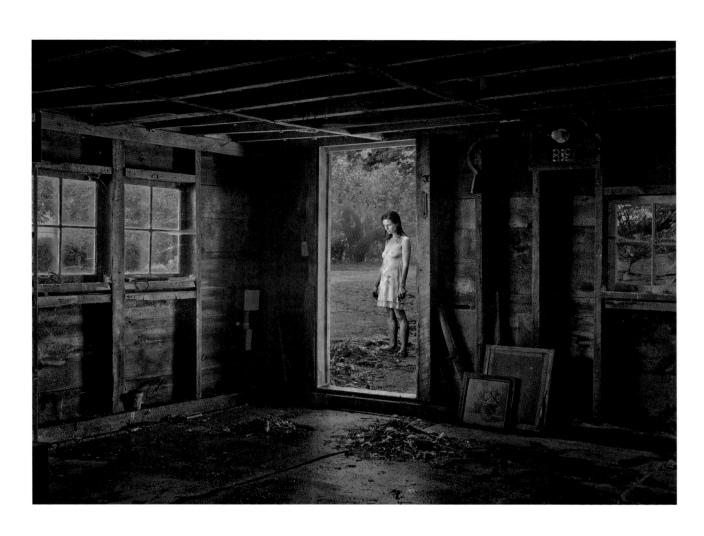

The Shed, 2013

NICK BRANDT

"My images are an elegy to a world that is steadily, tragically vanishing." This is how British photographer Nick Brandt described the compelling animal portraits that he took up until the year 2004. As his more recent work reveals to us, much of this world has sadly already vanished.

In 1995, Nick Brandt, a successful director of music videos, went to Africa for the first time, to shoot the video for Michael Jackson's "Earth Song." He was so fascinated by the landscape and wildlife that he decided to devote himself to photography of the disappearing natural world of East Africa. He began this work in 2000, and he now has an impressive trilogy of books (*On This Earth*, *A Shadow Falls*, *Across the Ravaged Land*) featuring stunning images of animals ranging from seemingly paradisiacal nature shots to the documentation of the devastation wrought by humanity. Unlike most photographers today, he relies on analog technology, photographing in medium format and later scanning his negatives. "I prefer film to digital, because I love the surprises and imperfections that you can get with film, the unexpected ways that light will sometimes interact with the negative, whereas for black and white, and the subject matter that I shoot, I find digital too clinical, too perfect. And technically perfect is not necessarily better or more interesting."

Brandt also eschews the use of telephoto lenses, as he wishes to avoid producing standard wildlife reportage to instead create intimate portraits of the animals: "I'm trying to capture the animals in just being—their personalities, their souls—and to photograph them in the exact same way as if I were photographing a human being." His choice of black and white is based on both artistic and content-related considerations. While the absence of color focuses the viewer's gaze on the essential, that is, the animal's expression, the use of black and white imparts the images with a timeless quality. Brandt in fact sees his work as the recording of a time already past, photographs of a dying world increasingly threatened by mankind. His most recent project clearly demonstrates just how much of this world has already been irretrievably lost. Bearing the title *Inherit the Dust*, the work reveals in alarming fashion the dramatic development taking place in many regions of Africa. Armed with life-size prints of previously unreleased animal portraits mounted on aluminum and plywood panels, Brandt photographed in locations where animals such as these once roamed in their natural habitats. In the image included here, the original portrait of the elephant dates from 2008. Yet today you will not find wilderness teeming with diverse fauna, but rather garbage dumps, roads, settlements, and industry.

In 2010, Brandt discovered that increasing numbers of the elephants—along with other wildlife—he had photographed were being slaughtered for their ivory; in response he cofounded, together with renowned conservationist Richard Bonham, Big Life Foundation, whose goal is to prevent the poaching of wildlife in the border region of Kenya and Tanzania. Today, with approximately three hundred rangers and more than forty permanent and mobile outposts, they are making a valuable contribution to the preservation of the spectacular wildlife in the region.

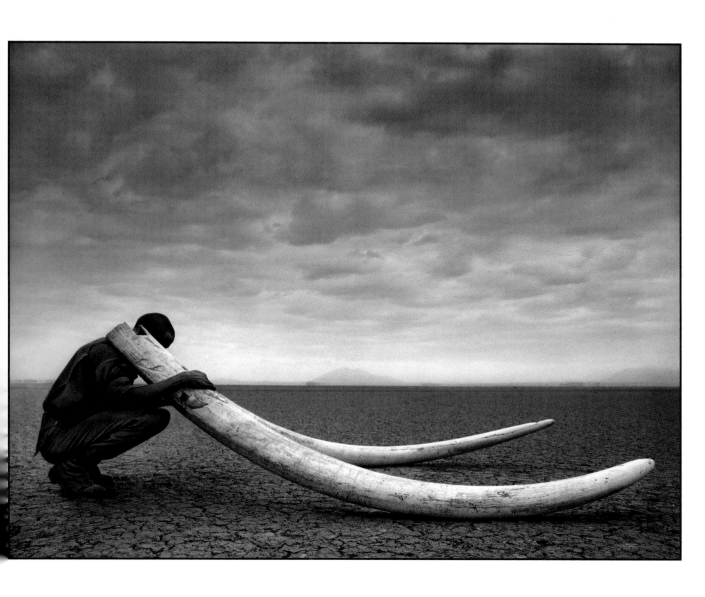

Ranger with Tusks of Elephant Killed at the Hands of Man, Amboseli, 2011

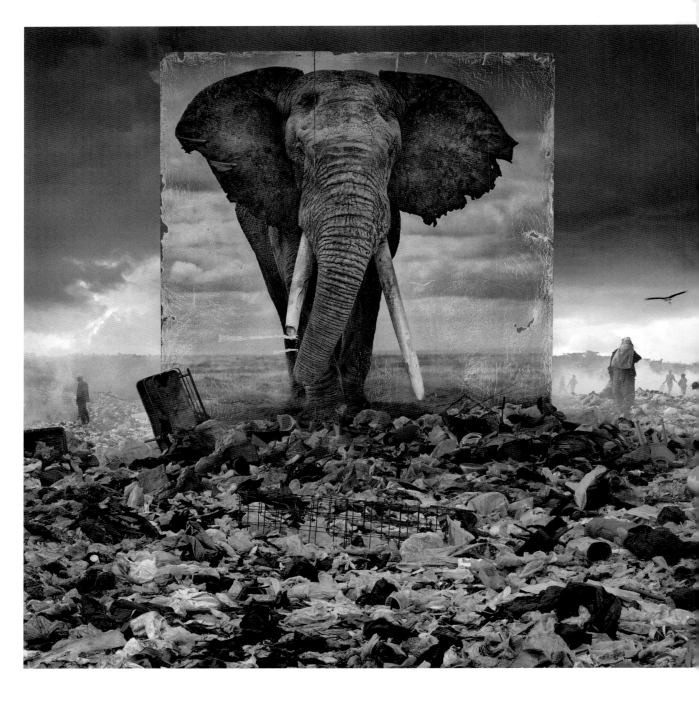

Wasteland with Elephant, 2015

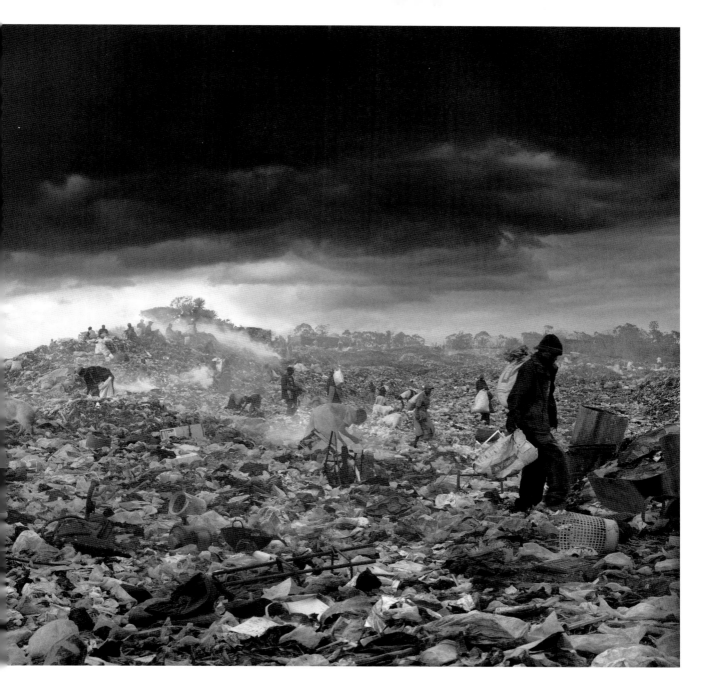

PAOLO PELLEGRIN

PAOLO PELLEGRIN

www.magnumphotos.com

Paolo Pellegrin photographs the world's crises, catastrophes, and wars. A member of Magnum Photos, he continues their noble tradition of great photographers documenting the planet in invariably poignant and striking images. In 1995, he won the first of his World Press Photo Awards—he has received ten to date—with a reportage about AIDS in Uganda. He has photographed the conflicts in Congo, the prison camp at Guantanamo, the consequences of the wars in former Yugoslavia, US forces in Iraq in 2003, the humanitarian catastrophe in Darfur in 2004, the apocalyptic landscape of northern Japan after the tsunami in 2011, and, repeatedly, the chronic conflicts in Israel and the Palestinian territories. His work is a bleak kaleidoscope of cruelty and violence and the consequences that people suffer.

Like many of his colleagues, Pellegrin faces the accusation of aestheticizing dramatic events. His pictures are subjective, black and white, and somber in tone: "I steer the viewer emotionally in a specific direction." He takes evocative photographs, at times blurry or in soft focus, that are, in a sense, open to interpretation and thus exchange and dialogue. They are images that raise questions and challenge the viewer: "Photography is only complete with the participation of the viewer. And that is always different," observes Pellegrin. His images are works of art in the sense that they go beyond the actual facts of the events depicted to say something about humanity and our lives and actions.

"I don't think that a lesser [aesthetically beautiful] photograph does more justice to a subject, or tells a story better, than a good one. On the contrary." In this context, Pellegrin does not see photoreportage in danger from those who find themselves in the situations he is covering, and who might take pictures on their phones and publish them. His role as a photographer is something else. Not only does he do intensive and in-depth research of the subjects that he documents, but he has also labored over the artistic aspects of his work and has developed his own visual language, a process that distinguishes his photography, like that of many of his colleagues, from pictures taken by ordinary citizens with a camera. The power and the idiosyncratic beauty of his images casts a spell over the viewer, and this allows the photographer to get people to think just a bit more about the things that are occurring in the world.

For several years now, Pellegrin has also been doing portraits of Hollywood actors and other celebrities for the *New York Times*, which at first seems rather surprising. He does not, however, create typically glossy portraits; even here he tries to dig deeper, that is, to look beyond the public façade of celebrity and ask questions, to create his subjective images: "Portraiture is not only a close-up of a face. . . . In all my work, I engage with the idea of saying something about something—be it a person or an issue."

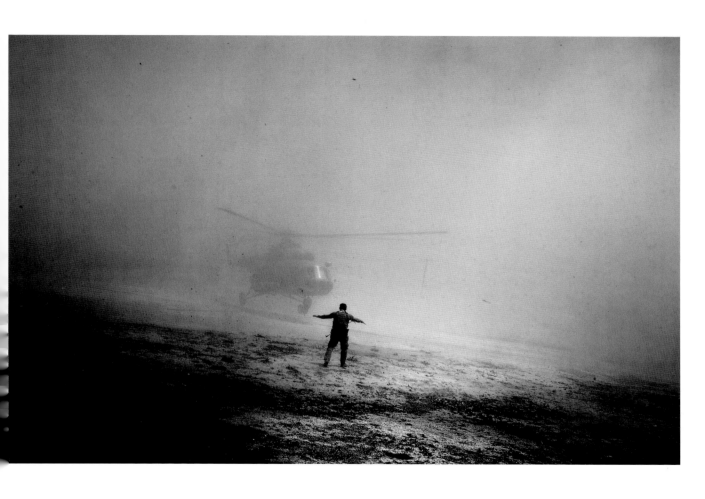

A Helicopter Used by the Drug Enforcement Agency and Afghan Troops Lands, after Completing a Mission, Kabul, Afghanistan, May 2006

41 JUERGEN TELLER

With his rough, sometimes trashy, unretouched photographs, Juergen Teller stands apart from the work of his high-gloss colleagues in the fashion industry. He is searching for the intrinsic character of his subject, without glamour, without a mask. He portrays people as they are.

After studying photography in Munich, Juergen Teller moved to London in 1986 and made a name for himself with his strikingly natural-seeming images. He gained access to the music scene and photographed musicians such as Björk and Sinéad O'Connor, who used a portrait by Teller as the cover for her global hit *Nothing Compares 2 U*, and the band Nirvana, still largely unknown at the time, who he accompanied in 1991 during the German leg of their *Nevermind* tour. Through his then girlfriend, a stylist who would became his first wife, Teller made contacts with the fashion world, and he quickly distinguished himself with his anything but glamorous photographs.

Teller has developed a straightforward, documentary style focused entirely on the moment the picture is taken, being more about what is actually happening before his lens than the typically staged productions of the fashion world. A simple frontal flash, harsh shadows, often accidental-looking compositions, no unusual perspectives or focal lengths—that is how he produces his unusual pictures. Teller's photographs subvert expectations associated with the fashion world, and show us how things really are. It can be a model without makeup, or with freckles, scars, or other natural "imperfections." It is, as his long-standing client the designer Marc Jacobs put it, "the imperfection of what's real." Teller is interested first and foremost in the individuals standing in front of his camera rather than the clothing. To do this, however, he also needs the complicity of designers and clients who understand this approach, as is the case with Jacobs, Helmut Lang, and Vivienne Westwood. Teller can thus direct attention away from the fashion and back to the person: "I [am] able to humanize the person wearing the clothes."

Underlying Teller's work for the most prestigious magazines is an ambivalent attitude to the fashion and advertising industries, in which he questions their almost surreally "perfect" worlds. We have seldom seen models like Claudia Schiffer and Kristen McMenamy, or other famous people known to us through countless images, looking more "real" than in Juergen Teller's images.

Although Teller has lived and worked in London and Cornwall for many years, he has maintained a strong connection to his Franconian roots near Nuremberg. He returns regularly to investigate his origins, his childhood, and his adolescence. The famous image featuring Teller naked while drinking beer and smoking on his father's grave is just one example of this personal exploration, reflected in books such as his 2004 *Nackig auf dem Fußballplatz* (Naked on the soccer field). Teller does not differentiate between art and commerce. He is often the subject of his pictures, as are famous people in rather unusual situations, such as Kate Moss in a wheelbarrow, Victoria Beckham in a shopping bag, a nude Charlotte Rampling in the Louvre, and Vivienne Westwood naked on a sofa. The fact that the pictures still "work" lies in the fact that many of his subjects feel that he understands them on a deep level, that he has created a recognizable style, and that he dares to show what other photographers try to cover up through glamour and perfection.

Kate Moss No. 12, Gloucestershire, 2010

Victoria Beckham, Legs, Bag and Shoes, Marc Jacobs Spring/Summer 2008 Campaign, Los Angeles, 2007

42 MARTIN SCHOELLER

"I am interested in the idea of documenting faces of our times," says the German photographer Martin Schoeller, who had first achieved renown in the United States before doing so in his native Germany. Meanwhile, he is considered one of the most interesting portrait photographers on either side of the Atlantic.

MARTIN SCHOELLER

As career preparation, Martin Schoeller could not have wished for a better job—technically speaking—than that as an assistant to Annie Leibovitz. Thus prepared, he began his own career in 1996, soon achieving a great deal of success. In 1999, he signed a contract with *The New Yorker*, becoming the successor of perhaps the world's most influential portrait photographer, Richard Avedon, who died in 2004.

His breakthrough came in 1998 with an unusually close portrait of the British actress Vanessa Redgrave for *Time Out New York*. With that image, Schoeller introduced the public to the style of portrait photography that would make him almost instantly famous: his "close-ups." In 1998, he'd had something like five assignments; the next year he had well over a hundred. Schoeller has a very clear objective: "Like most portrait photographers, I aim to record the instant the subject is not thinking about being photographed, striving to get beyond the practiced facial performance, reaching for something unplanned." Looking at how Schoeller's close-ups are created, it is hard to imagine how anyone could avoid thinking about being photographed: two large fluorescent lights are placed on either side of you, between them a medium-format camera, and behind that a photographer telling you that you should stop thinking about being photographed . . . And yet Schoeller succeeds in making precisely this happen, capturing, as he calls it, an "honest" moment. Moreover, one cannot really say that Schoeller's close-ups are flattering—far from it. They are in some respects even more unforgiving than traditional portraiture, because the subject has no way of hiding anything, no possibility of withdrawing. In Schoeller's portraits everything comes to light, the entire face. And it is closer and clearer than when we normally stand face to face with someone. There is nothing to distract the viewer, no context to explain the face being portrayed. In that respect, Schoeller's portraits are truly "democratic." It makes no difference whether the subject in front of the camera is US president Barack Obama or German chancellor Angela Merkel, two of the most powerful people in the world, or the homeless of Los Angeles, who Schoeller has been taking portraits of for a West Hollywood charity since 2015. Everyone is subject to the same lighting, the same distance from the camera, the same framing. The only thing that differentiates the people in Schoeller's close-ups is the fact that some we don't know, while others we think we do. Not everyone, however, is delighted by their portraits; the actor Steve Buscemi, for example, refused to allow his picture to be published. But Schoeller does not limit himself to just close-ups; he also takes what he has called "funny and smart pictures," delightfully staged scenes that tell little stories about the people he has in front of his lens.

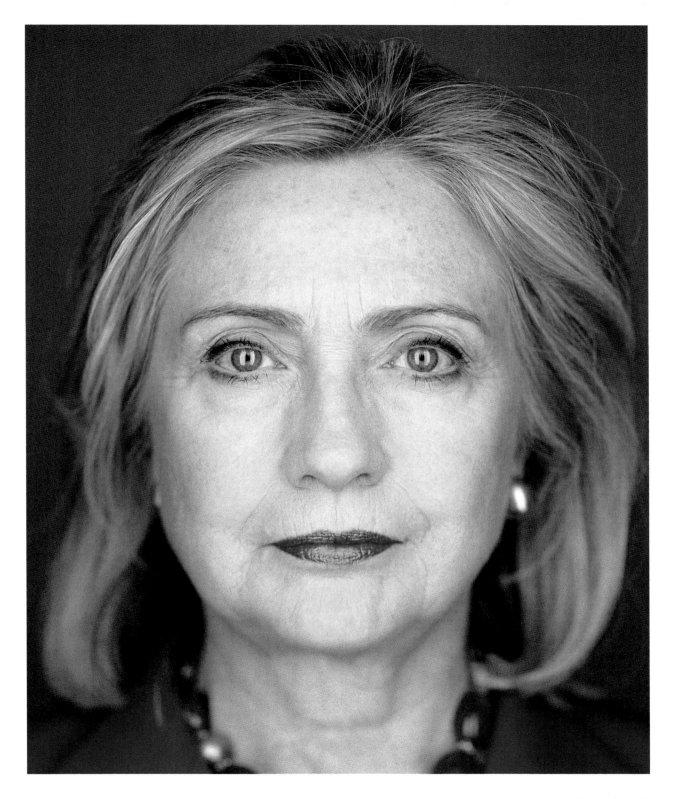

Hillary Clinton, 2015

43 WOLFGANG TILLMANS

Exploring everything from traditional street photography to "abstract" art produced in the darkroom, Wolfgang Tillmans has significantly expanded the definition of "artist photographer." His incredible versatility as well as his facility with light and color won him the prestigious Turner Prize in 2000.

WOLFGANG TILLMANS

1968 Born in Remscheid, Germany

1990–92
 Studied art and photography at the Bournemouth and Poole College of Art and Design, England

1993 First solo exhibition at Galerie Buchholz in Cologne

ca. 1998
 Began creating abstract works based on photographic processes

2000 Became the first photographer to win the British Turner Prize for art

2015 Hasselblad Foundation Award

Wolfgang Tillmans has made art with an impressive variety of styles and techniques. Born in 1968 in Germany, he achieved international fame while studying and working in England. He photographed scenes of London's urban culture that were both spontaneous and precisely detailed. His best-known works from this period include richly colorful still lifes showing plates of food, dirty dishes, and cigarette lighters, scenes that poke fun at the slightly chaotic nature of city living. A later series of London images, this time featuring riders on the Tube, began to shift Tillmans's art toward abstraction. His photos of the London underground scene capture only details: an armpit exposed under a T-shirt or a man's closely cut hair against a denim sleeve. Tillmans stated that these images could be thought of as "mere studies of surface textures." Yet, they also reveal uncomfortable social realities: the "incredible intimacy of people, without them wanting to be intimate with each other."

In the late 1990s, Tillmans began to experiment with the photographic process itself. He produced striking pictures by manipulating photographic paper in the darkroom. One series of images that came out of this process was called *Freischwimmer* (2003–12). These works have the look of abstract paintings, often with thin lines and supple shapes that seem to "swim" across the page.

Tillmans has also experimented with unusual installation methods. For example, he has displayed his photos as part of larger, collage-like arrangements—arrangements that also include newspaper texts, packaging material, and postcards. These installations blur the distinction between photographic and conceptual art. They also give the viewers a chance to assign their own interpretations as to the artist's "meaning" or "intent."

Tillmans's interest in art has also included teaching. He has worked at the Hochschule für bildende Künste Hamburg and at the Städelschule in Frankfurt am Main. In 2000, he became the first photographer—and the first German—to win the Turner Prize. Such recognition acknowledges the creativity with which Tillmans has explored "how an industrially produced piece of paper becomes an object of great beauty and meaning with the mere addition of light."

Freischwimmer 199, 2012

still life Cambridge Heath Road, left over, 2011

44

ALEC SOTH

Alec Soth stands in the grand tradition of American photographers—like Walker Evans, Robert Frank, Stephen Shore, and Joel Sternfeld—who, each in their own way and each in their own time, went on the Great American Road Trip and contributed a vibrant image of their country.

ALEC SOTH

It was always one of Alec Soth's goals to travel the United States by van and take pictures of the places he found interesting. Joel Sternfeld, with whom Soth took two classes in college, once raised the question as to whether the traveling and searching for subjects might not be the actual art, and photographs themselves a mere by-product. For Soth, however, the photographs are by no means a by-product—quite the contrary. Like many of his colleagues, he works in series or projects for which he first develops a concept and then carries it out: "I think in narrative terms, the way a writer thinks of a book, or a filmmaker of a film." At the same time, Soth sees a problem with photography: "Photographs aren't good at telling stories. Stories require a beginning, middle, and end. They require the progression of time. Photographs stop time."

Alec Soth often works with an 8×10 field camera. For him the choice of camera is of considerable importance, because one naturally works with a large-format camera in a fundamentally different way than with a smaller digital model. His first three monographs, *Sleeping by the Mississippi* (2004), *Niagara* (2006), and *Broken Manual* (2010), were all shot in large format. Setting up the camera is a slow process, after which one disappears under a large cloth to focus. The crucial moment with a field or view camera is observing the subject on the large ground-glass screen, on which the image appears like a painting, albeit upside down. Using such a camera, Soth develops a different relationship with, and a certain distance from, his subjects, producing a photograph that, as he describes it, "is often a picture of the space between us." Partly due to the technology he uses, Soth creates haunting images and—as those portrayed are all too aware—intimate portraits. He has said, "To me the most beautiful thing is vulnerability." Through his work he reveals himself to be a sensitive observer with a keen sense of humor who discovers fascinating, disturbing, and rather curious situations and people. He photographs people's loneliness and aspirations. He may, for example, ask his subjects to write down their dreams, or photograph their love letters. For *Songbook* (2015), which he shot in digital black and white, he used as a guide another American myth, the Great American Songbook, the definitive collection of music from the 1930s to 1960s. Through his travels for his books, Soth became the chronicler of a vast provincial America lying between New York and Los Angeles, an endless source of the new and the surprising, if one is prepared to engage people—and nothing is more appropriate for that than photography.

But his creativity can also come out in other ways: invited in 2010 by Martin Parr to take part in the Brighton Photo Biennial, Soth was prohibited from taking pictures because he lacked a UK work permit, so he gave his camera to his then seven-year-old daughter. The photos she took of Brighton were exhibited, and no one noticed anything unusual.

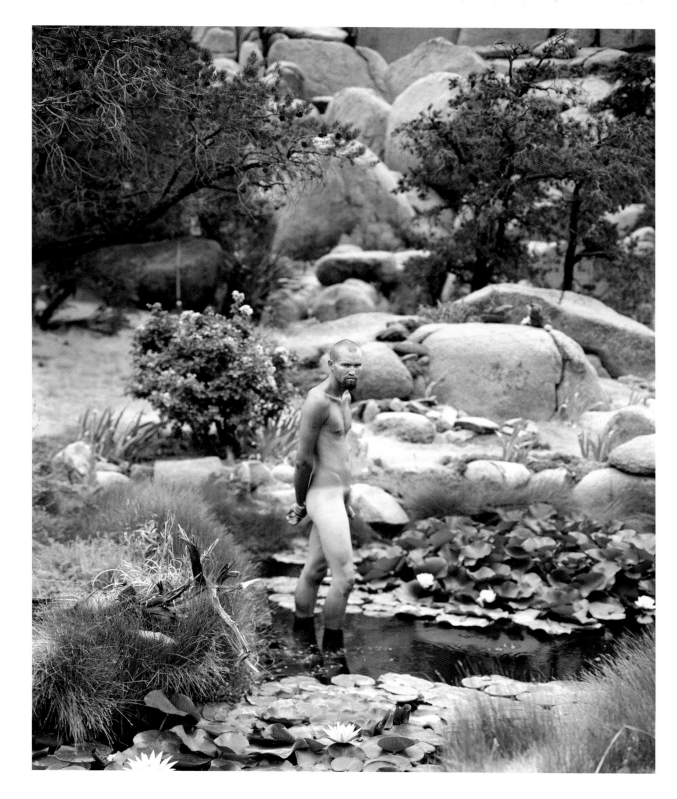

USA, 2008

RINKO KAWAUCHI

For a young photographer to first present her work with the simultaneous publication of three books, and for her to have such a profound impact on the art world, the photography must be quite remarkable. As it is with Japanese photographer Rinko Kawauchi.

RINKO KAWAUCHI

www.rinkokawauchi.com

The images in the three books—*Utatane*, *Hanabi*, and *Hanako*—published in 2001, as well as those in other photo series by Rinko Kawauchi, have a unique radiance and appeal. A bird at the very moment of taking flight, a bead of sweat on the skin, a view into a tunnel, the glowing tip of a cigarette, a poppy bursting into flower: they are motifs that Kawauchi assembles in her books to create a kind of optical poem. As with poetry, the associative possibilities in Kawauchi's photography are boundless and by no means prescribed by the images or the sequencing. "In poetry we extract tiny fragments from reality," explains the artist. "Each word is an image, and they are connected in a special way. And that is how I see my photos, not as individual images but as parts of a series, only upon the completion of which does the new whole emerge." The book is her preferred medium, because it allows a certain closeness and intimacy between the images and the viewer.

They are intimate observations of everyday details, reflections, and impressions that are revealed in light, nuanced colors. Though in color, the photography's delicacy as well as the photographer's resoluteness in intuitively encapsulating a motif is reminiscent of Sumi-e, Japanese ink wash painting. In this ancient art form, as in poetry or in Kawauchi's photography, things are hinted at rather than pronounced. In her first series, the images are extrinsically contained by the austere square format of the Rolleiflex camera she uses. This external austerity emphasizes the internal freedom of the images. The photographer long preferred the square format because, as she has said, it shows a "world that is neither vertical nor horizontal." In 2010, Kawauchi was invited by guest curator Martin Parr to the Brighton Photo Biennial, and there for the first time she took photographs digitally. In the process she broke away from the square—that had given her images a formal resoluteness—and thus also loosened up the exterior form.

There is a floating quality in her photographs, and at times something somber. "Darkness is an important metaphor and a key to my work," she observes. "Duality—brightness and darkness, life and death—is a central element of my work. There can be no light without darkness—and vice versa." The viewer can find within her images fundamental questions about the cycle of life, triggered by the detailed observations and the thoughts that accompany them, or, as the photographer simply puts it, "I want to understand what it means to be alive."

Rinko Kawauchi, whose favorite color, incidentally, is blue, is also quite remarkable within contemporary photography for another reason, focusing as she does on something we might think no longer has a place in it: beauty.

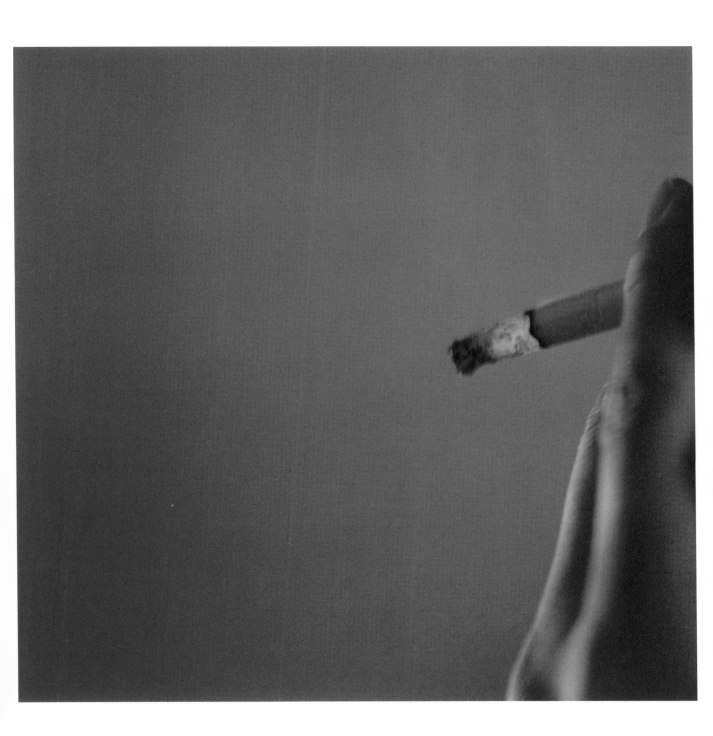

Untitled (from "Illuminance"), 2009

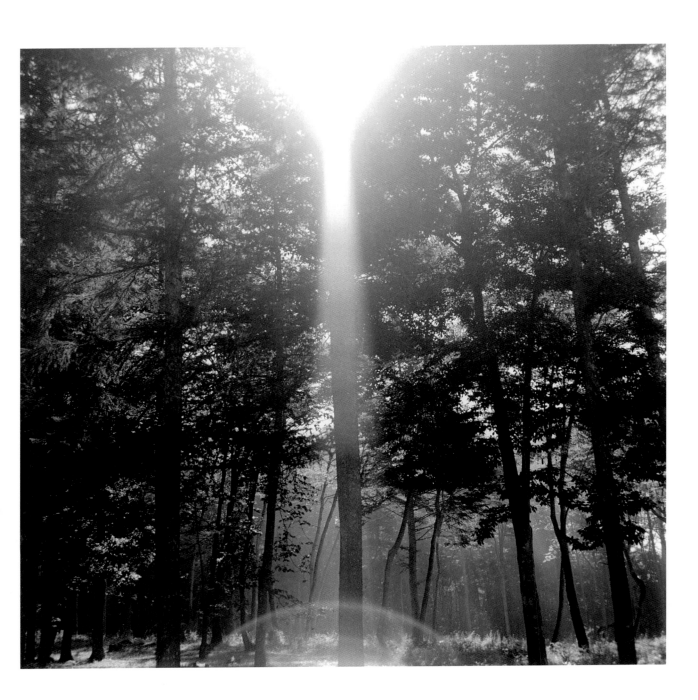

Untitled (from "Illuminance"), 2009

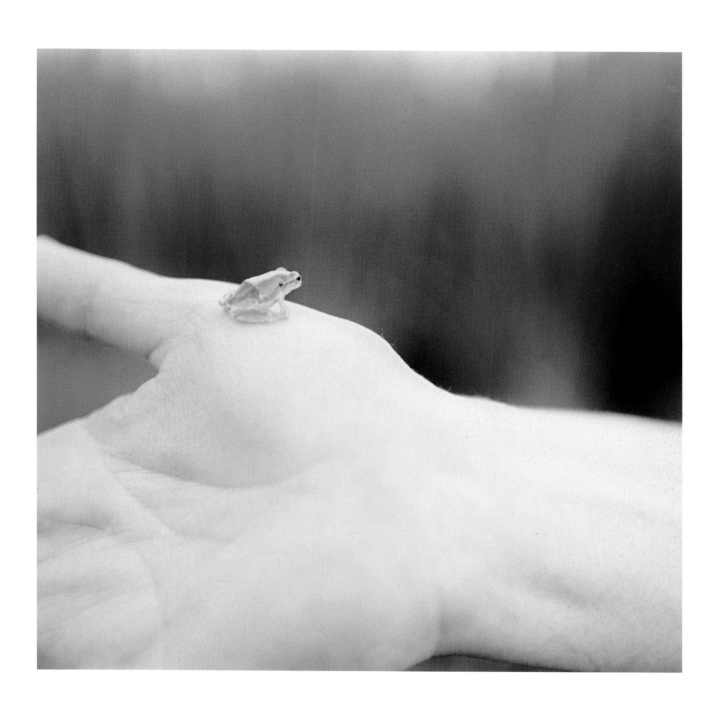

Untitled (from "Illuminance"), 2009

46

ZANELE MUHOLI

South African photographer Zanele Muholi is a master portraitist of an entire community. She presents black LGBT people in her home country with unprecedented depth and strength, often using her own image to achieve her artistic and social goals.

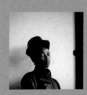

ZANELE MUHOLI

1972 Born in Umlazi, Durban, South Africa

2003 Completed a photography program at the Market Photo Workshop in Johannesburg

2004 First solo exhibition

2009 Received her MFA from Ryerson University in Toronto

2009 *Faces and Phases* exhibition

2010 Codirected the documentary film *Difficult Love*

2013 Appointed honorary professor at the University of the Arts Bremen

"In the face of all the challenges our community encounters daily, I embarked on a journey of visual activism to ensure that there is black queer visibility. *Faces and Phases* is about our histories and the struggles that we face. *Faces* express the person, and *Phases* signify the transition from one stage of sexuality or gender expression and experience to another. *Faces* is also about the face-to-face confrontation between myself as the photographer/activist and the many lesbians, women and transmen I have interacted with from different places."

Zanele Muholi uses her art to reveal a community that has long been pushed into the shadows. As a South African who is both black and lesbian, Muholi aims to improve the lives of black LGBT individuals who still suffer social, economic, and sometimes violent forms of discrimination in their own country. When perpetrated against lesbians, such violence may even include a type of rape that is intended to "cure" the woman of her "deviant" sexual orientation. Many of Muholi's best-known works are her sensitive self-portraits, often showing her as strong, engaged, and self-confident in her individuality. The black-and-white self-portrait from 2011, shown here, is typical of such works. The artist's gaze seems both confrontational and sensitive, inviting the viewer to contemplate the subject's life experiences—her childhood under apartheid and her current role in organizations that provide career training and safe havens for lesbian South Africans under duress. This portrait was part of a larger project, entitled *Faces and Phases* (begun in 2006), that featured other community leaders doing work similar to Muholi, individuals who otherwise would never have received the public "visibility" they deserved.

More recently, Muholi has been capturing the rituals that bind her community together. In the exhibition *Of Love & Loss* (2014), she portrayed both weddings and funerals among South Africa's LGTBs—showing both pain and celebration side by side. This exhibit seemed to reflect South Africa's own internal conflicts. It was among the first nations to recognize same-sex marriages, yet the struggle for true gender equality remains daunting.

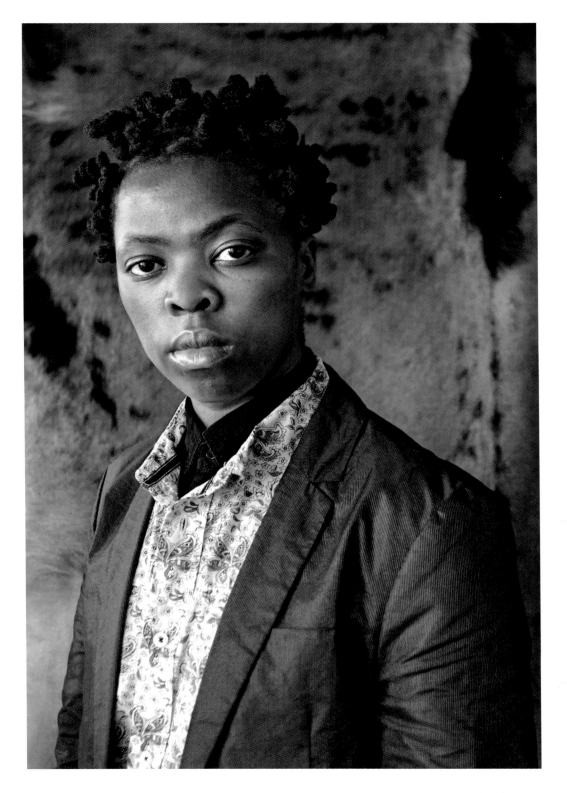

Zanele Muholi, Vredehoek, Cape Town, 2011

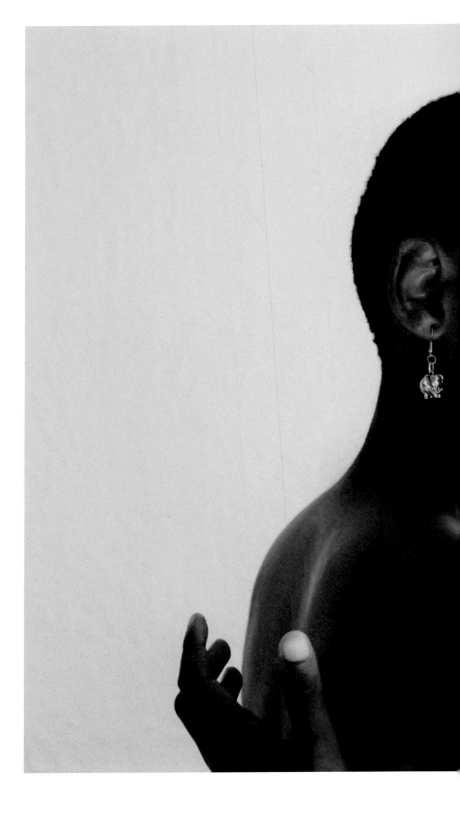

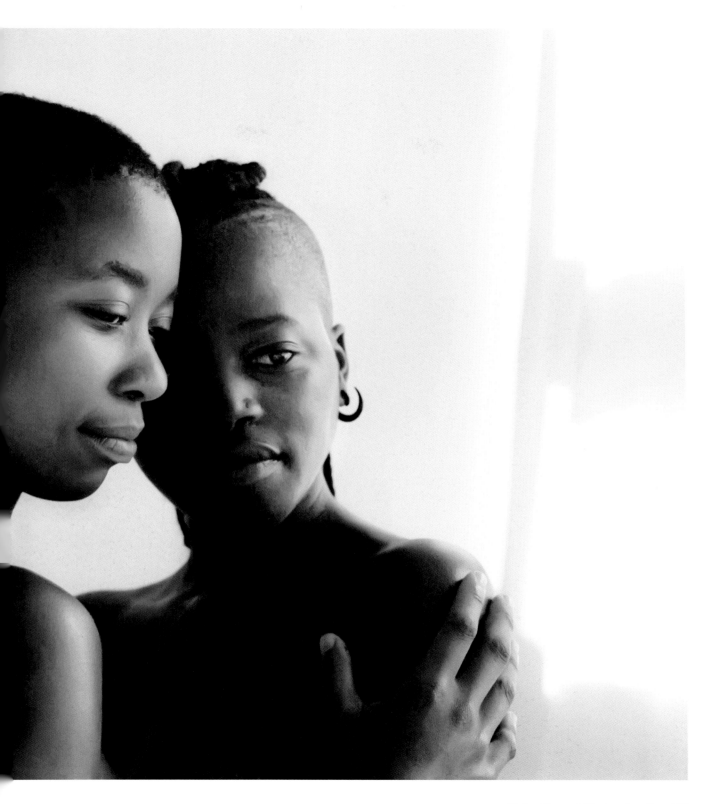

Zinzi and Tozama II, Mowbray, Cape Town, 2010

VIVIANE SASSEN

Observing the form that fashion photography assumes at any given moment is a constant source of fascination. While naturally as varied as the fashion industry itself, it often takes a strangely critical distance given the purpose it ultimately serves.

VIVIANE SASSEN

1972 Born in Amsterdam, Netherlands

1974–76
 Lived in Kenya with her parents

1990–97
 Studied fashion design, photography, and art in Arnheim and Utrecht

2008 *Flamboya*

2011 *Parasomnia*

2011 Infinity Award: Applied/Fashion/Advertising Photography, International Center of Photography

2013 German Photo Book Prize for *In and Out of Fashion*

2016 German Photo Book Prize for *Umbra*

www.vivianesassen.com

Fashion photography is invariably a compromise between the commercial needs of the customers and clients, and the photographer's artistic aspirations and ideas. At times the models are put so much in the spotlight that the fashion is almost forgotten, such as in Peter Lindbergh's work; or fashion photography seems to be a mere pretext for critically questioning the entire industry, as in the work of Juergen Teller. Or at times fashion is so prominent that the models presenting it seem to become just another "material," as in the work of Dutch photographer Viviane Sassen: "The body is a tool for me. It is my clay, my material, which I mold into an exciting shape." And indeed many of Sassen's photos look as if someone had molded a piece of humanity and left it lying somewhere for her to mindfully photograph. Yet her gentle and humorous view of women and men is determined less by stories she wishes to tell than by formal criteria. Bright, sometimes nearly glaring light, harsh shadows, strong colors, sculptural poses, structures, and graphic details are the formal elements of her photographs. She also features recurring visual motifs, such as long, thin legs, people entwined or connected in various ways, and also mirrors, which for Sassen open a door to the "other side" and represent a step into a parallel universe—as well as being the traditional symbol of vanity, something already omnipresent in fashion.

There are almost no images in which the models simply look beautiful—if one can see their faces at all. Sassen typically tries to avoid such images, in order to avoid approximating portrait photography. Yet her work is generally humorous, light, and playful. It is as if an artist had photographed sketches of ideas for sculptures still to be created—which seems entirely possible for Sassen. So we often see bizarrely twisted bodies and torsos standing among plants, or draped in cloth like a Pietà, or simply lying on the ground as if they have just fallen. Or a model becomes a giant blue and yellow flower in the middle of a pink field of tulips. One need not imagine anything when viewing these images. Sassen does not look to convey any narrative, or message. They are playful images involving bodies and light. As she explains, "I have a love-hate relationship with fashion; for me it is simply a platform for my photography, for my creativity. I see it more as a kindergarten, a playground for my inquiring mind."

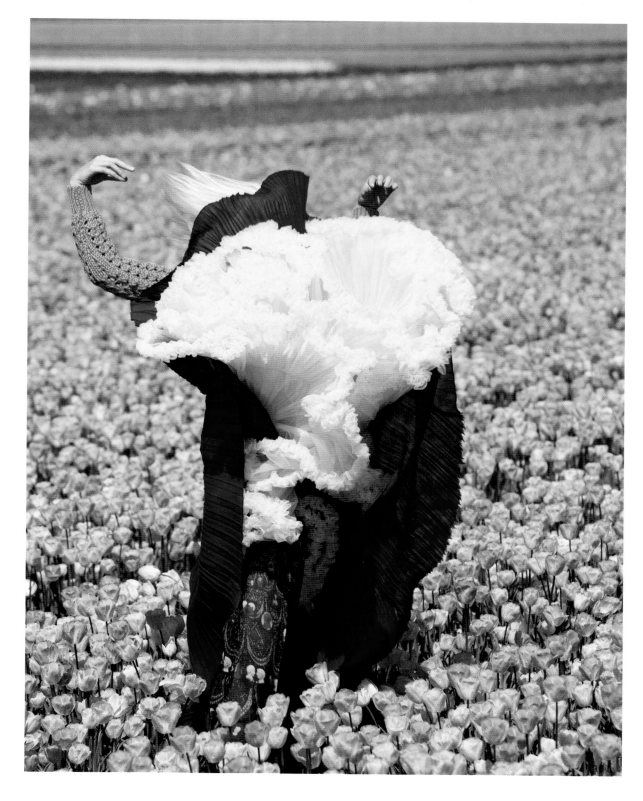

In Bloom (from "In and Out of Fashion"), 2011

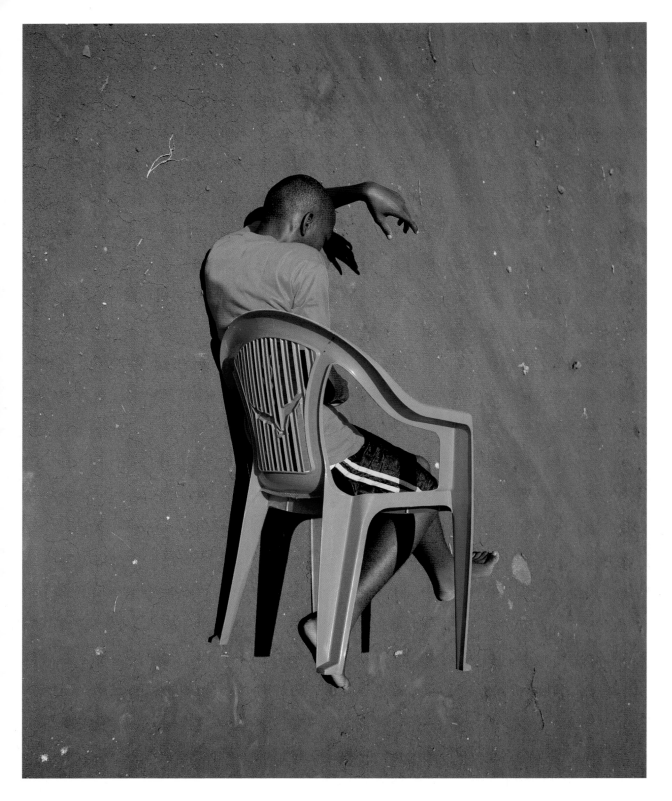

Parasomnia (from "Parasomnia"), 2010

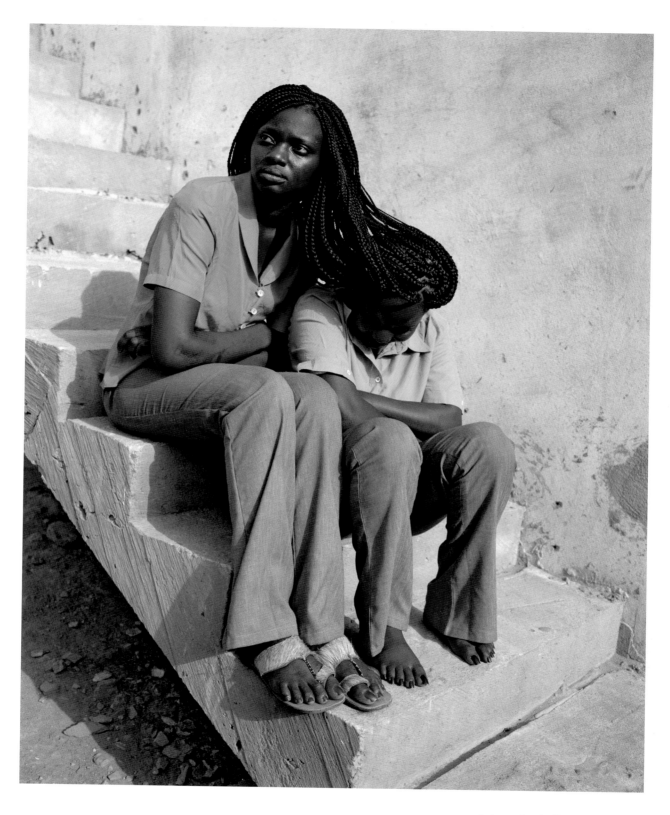

Darkuman Junction (from "Flamboya"), 2007

48

PIETER HUGO

"My homeland is Africa, but I'm white. I feel African, whatever that means, but if you ask anyone in South Africa if I'm African, they will almost certainly say no. I don't fit into the social topography of my country and that certainly fueled why I became a photographer."

PIETER HUGO

This otherness has always been a theme in Pieter Hugo's life and is also an important theme in his work. Assignments for photojournalists often require a certain inconspicuousness, and in South Africa a white man standing nearly two meters tall may not be the most suited for the job. So he began to distance himself from classic reportage and to develop a different kind of artistic documentation, in which he already stands out with his medium- and large-format cameras and can thus concentrate on his subjects. Hugo deals with outsiders and those on society's margins, and became known for his series of "Hyena Men," whom he photographed in 2005–07. A combination of street performer, medicine man, and artiste, they put on shows in the suburbs of the Nigerian capital of Abuja with hyenas, baboons, and snakes, and sell potions, herbs, and amulets. The images reveal an archaic world as it encounters our modern reality. The varied reception to the work is interesting: while in Europe and the US the focus is primarily on animal rights, in Africa people reacted more to the living conditions of the "Hyena Men." Another acclaimed series, *Looking Aside* (2003–06), features people who look different, such as African albinos, and, occupying a difficult position outside of society, who often suffer from persecution and discrimination.

The project *Permanent Error* (realized 2009–10) explores the living conditions on the world's largest garbage dump for electronic waste, in Agbogbloshie, a suburb of the Ghanaian capital of Accra. Here people eke out a living by burning old computers and mobile phones in order to extract the valuable raw materials. The inhabitants of Agbogbloshie thus live off the remains of an affluent society and grow sick from the toxic fumes produced by our consumerist waste. Hugo does not show this journalistically but in the form of highly focused portraits that capture the essence. From Oliviero Toscani, with whom he worked in Toscani's Fabrica in Treviso, he learned a maxim about the economy of the image: "If it's not essential with what you are showing, leave it out of the picture." Hugo's view of people on the fringes of society is often criticized as voyeuristic, a charge to which Hugo has responded, "I am looking because I am interested in looking. I want to look, and I want to look without apology. And with the intensity that I want to look with, I want to be looked back at. And if you can get that in a portrait or in a landscape, you have an energy."

In the twenty years since the end of Apartheid, South Africa has become increasingly more complex and sophisticated, and artists and photographers such as Pieter Hugo are looking for new opportunities and forms of expression to examine the still controversial subjects of politics, homeland, and racial identity. In his latest project, *Kin*, an intensive portrait of his native country, Hugo explores current living conditions and once again questions the state of South African society and where his place in that society really is.

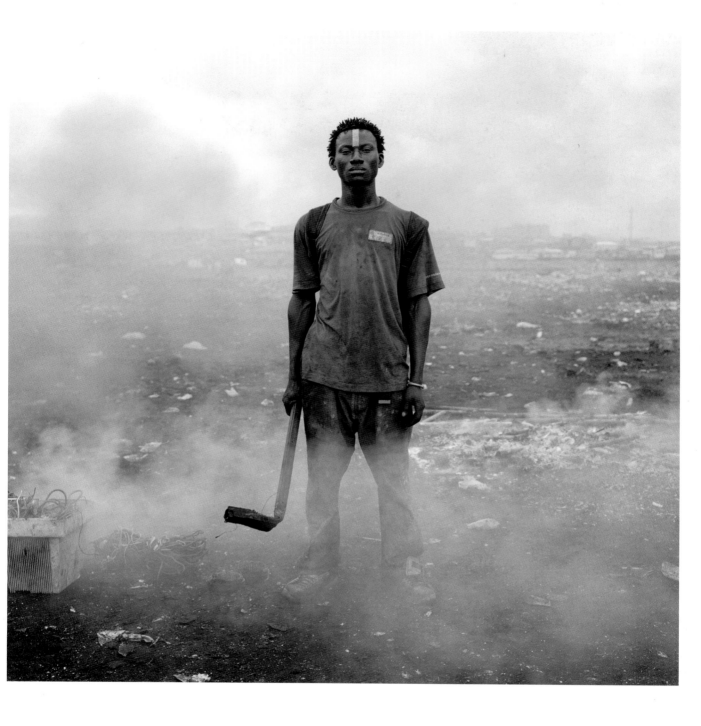

Aissah Salifu, Agbogbloshie Market, Accra, Ghana, 2010

49

RYAN MCGINLEY

Ryan McGinley became a leading chronicler of his generation at the turn of the millennium. His colorful, vivacious photos of street life in New York City earned the twenty-something several major awards and exhibitions. Today, his career remains immersed in both the art world and popular culture.

RYAN MCGINLEY

1977 Born in Ramsey, New Jersey, USA

1997–2000 Studied at the Parsons School of Design, New York

2003 Solo exhibition at the Whitney Museum of American Art

2003 Named Photographer of the Year by *American Photo* magazine

2010 *Everybody Knows This Is Nowhere* exhibit, featuring a series of nudes

2013–15 His massive *Yearbook* exhibit is held in different museums in North America and Europe

"Everyone kind of starts out shooting black-and-white photos, or shooting their food, or taking photos of their family, or doing a documentary project. You start to do all these things and then you start to check off stuff that you don't like. For me, I realized that [I liked taking photos of] the people I identified with—artists who were sort of antiauthority and came out of a skateboarding scene. . . . I later realized that I loved movement, which comes from my skateboarding and snowboarding background. I also loved dancing and I loved going out and partying, so I try to incorporate that feeling—people moving like they're on a dance floor—into my work."

Ryan McGinley has used his love of movement, nature, and antiestablishment culture to create a remarkably energetic and distinctive photographic style. During his early years in New York City, when he was studying at the Parsons School of Design, McGinley captured the frenetic social world of his peers in the book *The Kids Are Alright*. His subjects are shown exploring limits: spraying graffiti, appearing nude in public, and hanging off the walls of buildings. McGinley's images brilliantly document this restless world, often showing people slightly blurred and in mid-motion. They revealed a new generation coming of age at the millennium, yet the artist has argued that they also represent a continuation of the past. "I think that my early photos contributed to a tradition of photographing downtown New York that had already been in place. From Allen Ginsberg and the beatniks, to the Warhol posse, to David Armstrong or Nan Goldin or Jack Pierson, everyone has photographed their scene in New York, and I was definitely contributing to that lineage." McGinley's fame would soon approach that of his early mentors, and in 2003 he became one of the youngest artists to have a solo exhibition at the Whitney Museum of American Art.

One photo from McGinley's early period, entitled *Tree #1*, reveals the restless nature of his imagery. The nude revelers, surrounded by a hazy light, seem to be disappearing into the tree. Though the scene is captured in a "natural" environment, the harsh lighting on the outer tree branches makes it appear more like an urban stage set, with its subjects the main performers. More recently, McGinley's work has focused on rural areas, especially in Upstate New York. These images feature an increasing interest in brilliant colors achieved through digital techniques. The artist has also used the digital world to promote and disseminate his work, such as his lavish Instagram account at #ryanmcginley.

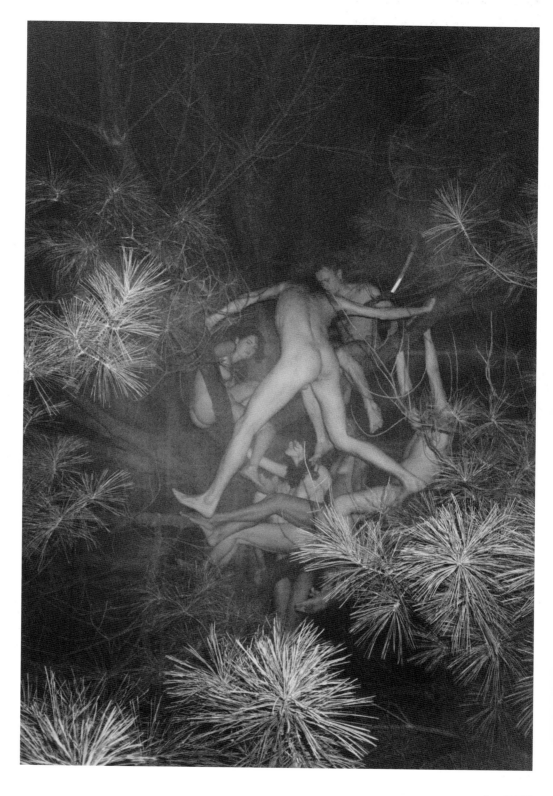

Tree #1, 2003

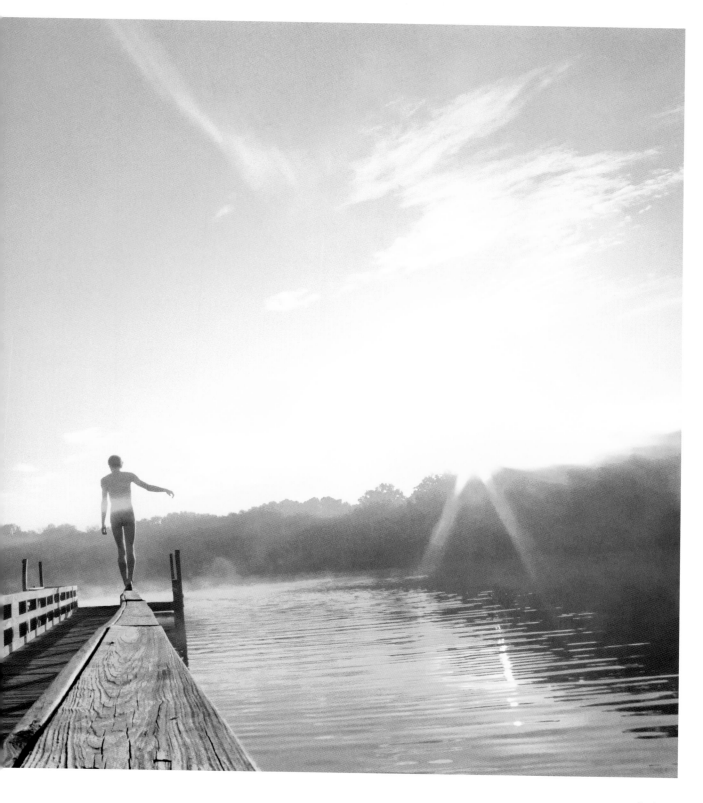

Dock, 2013

50

RICHARD MOSSE

Richard Mosse is not a war photographer in the traditional sense. Through extraordinary and unconventional means he attempts to bring two very distinct worlds together—that of war and that of art: "I believe," he says, "that beauty is the sharpest tool in the box."

RICHARD MOSSE

1980 Born in Kilkenny, Ireland

1998–2001
 BA in English Literature and
 Language, King's College London

2002–03
 MRes in Cultural Studies, London
 Consortium

2006–08
 MFA in Photography, Yale University School of Art

 Reportages in Haiti, Iran, Pakistan

2013 *The Enclave* (film and book),
 with which he participated at
 the Venice Biennale (video installation)

Since 2015
 Nominee Member, Magnum
 Photos

www.richardmosse.com

The question of how to aptly document war and other political and military conflicts, or even comment upon them, has occupied photographers since the first conflict images were in the 1850s during the Crimean War. To represent the years of conflict in the Congo, Irish photographer Richard Mosse has found a very personal answer. Always looking for new opportunities, in 2009 he learned that Kodak was to cease production of its Aerochrome color infrared film. Aerochrome is a special film stock sensitive to nonvisible, infrared light, which is reflected, for example, by green vegetation. In images taken with this film, plants do not appear green but rather in tones between pink and red. The film was developed in the 1940s for military reconnaissance, to assist the identification of enemy positions in forested areas. Mosse purchased large quantities of the remaining film stock and traveled to the Congo to document the war that had been raging since 1998—largely unseen by the Western public—and that has claimed over 5.4 million victims to date. He decided to carry out an artistic-documentary experiment: with his 8×10 camera and the infrared film, he photographed landscapes as well as militias, individual soldiers, and victims. The surprisingly unique documentary images that resulted present the conflict in a different light—in this case, also literally: "This idea of making the invisible visible fascinated me. I use this film to make the invisible conflict, the forgotten disaster, visible. In addition, the color palette of the film is extremely surprising, very kitschy. People have never seen war like this. So I hope they take a second look."

The reddish-pink color lifts Mosse's subjects out of documentary normality and exaggeratedly places them into the realm of the surreal, even that of the beautiful. What seems disturbing at first glance thus acquires upon closer examination a deeper meaning on several levels: "If you can seduce the viewer and you can make them feel aesthetic pleasure regarding a landscape in which human rights violations happen all the time, then you can put them into a very problematic place for themselves. . . . It forces the viewer to meditate on how imagery from conflict is constructed in the first place."

The artistic approach suits the bewildering complexity of this military conflict. What is also remarkable is the fact that this "invisible" war is being brought back into the public eye using a material designed for military reconnaissance. Looking to expand the boundaries of documentation, Mosse succeeds in treading the fine line between art and documentation, and in confronting the viewer with the discrepancy between horror and beauty. In 2012, Mosse shot the documentary *The Enclave*, which he realized with 16mm Aerochrome film, and in 2013 it was featured as Ireland's representation at the Venice Biennale. Mosse speaks of a hidden reality that he wishes to make people aware of through his work. His extraordinary photography has indeed attracted considerable attention worldwide—focused not only on his work but also on the actual conflict.

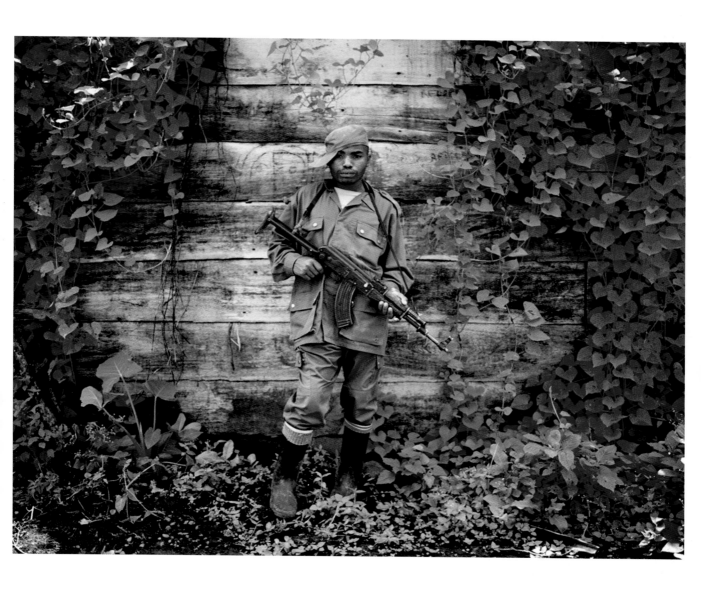

Dead Leaves and the Dirty Ground II, 2011

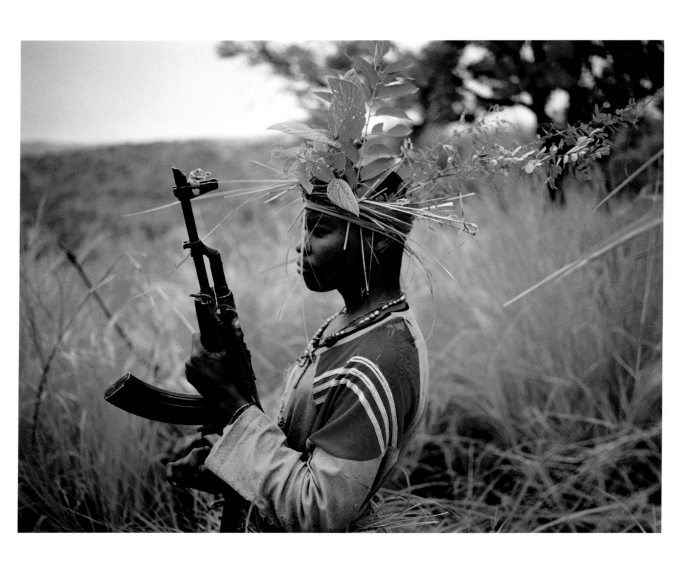

Safe from Harm, 2012

Platon, 2012

PORTRAIT ILLUSTRATIONS

Cover: Richard Mosse, Platon, 2012, page 155
Frontispiece: Ryan McGinley, Dock, 2013, pages 150/151

Texts by Brad Finger on pages: 20, 28, 32, 38, 42, 86, 100, 128, 138, 148
Texts by Florian Heine on pages: 8, 10, 12, 16, 18, 22, 24, 30, 36, 46, 48, 50, 52, 56, 60, 62, 66, 68, 70, 74, 78, 82, 88, 90, 92, 96, 102, 104, 106, 110, 114, 116, 118, 122, 126, 132, 134, 142, 146, 152

© Prestel Verlag, Munich · London · New York 2016
A member of Verlagsgruppe Random House GmbH
Neumarkter Strasse 28 · 81673 Munich

In respect to links in the book, Verlagsgruppe Random House expressly notes that no illegal content was discernible on the linked sites at the time the links were created. The Publisher has no influence at all over the current and future design, content or authorship of the linked sites. For this reason Verlagsgruppe Random House expressly disassociates itself from all content on linked sites that has been altered since the link was created and assumes no liability for such content.

Prestel Publishing Ltd.
14-17 Wells Street
London W1T 3PD

Prestel Publishing
900 Broadway, Suite 603
New York, NY 10003

Library of Congress Control Number: 2016949018

A CIP catalogue record for this book is available from the British Library.

Editorial direction:
Adeline Henzschel, Claudia Stäuble
Copyediting: Jonathan Fox
Proofreader: Leina González Baird
Translation: Jane Michael
Picture editing: Andrea Weißenbach
Cover design: Sofarobotnik
Design: normal industries
Layout: Wolfram Söll
Production management: Astrid Wedemeyer
Separations: Reproline Mediateam
Printing and binding: Druckerei Uhl

Paper: Primaset

Verlagsgruppe Random House FSC® N001967

Printed in Germany

ISBN 978-3-7913-8259-3
www.prestel.com

ROGER BALLEN
*1950

STEVE MCCURRY
*1950

PHILIP-LORCA DICORCIA
*1951

SALLY MANN
*1951

MARTIN PARR
*1952

ALEX WEBB
*1952

SOPHIE CALLE
*1953

NOBUYOSHI ARAKI
*1940

NAN GOLDIN
*1953

SARAH MOON
*1941

MICHAEL KENNA
*1953

CANDIDA HÖFER
*1944

CINDY SHERMAN
*1954

SEBASTIÃO SALGADO
*1944

THOMAS STRUTH
*1954

TINA BARNEY
*1945

ELLEN VON UNWERTH
*1954

DAVID BAILEY
*1938

ELI REED
*1946

EDWARD BURTYNSKY
*1955

JOSEF KOUDELKA
*1938

JEFF WALL
*1946

ANTON CORBIJN
*1955

JOEL MEYEROWITZ
*1938

STEPHEN SHORE
*1947

ANDREAS GURSKY
*1955

BORIS MIKHAILOV
*1938

SUSAN MEISELAS
*1948

PAUL GRAHAM
*1956

DAIDO MORIYAMA
*1938

HIROSHI SUGIMOTO
*1948

THOMAS RUFF
*1958

WILLIAM EGGLESTON
*1939

ANNIE LEIBOVITZ
*1949

RINEKE DIJKSTRA
*1959

| 1930s | 1940s | 1950s |

TIMELINE